# STUDIOS
# FOR
# ARTISTS

CONCEPTS

AND

CONCRETE

# STUDIOS FOR ARTISTS

## CONCEPTS AND CONCRETE

**A COLLABORATION BETWEEN ACME STUDIOS AND CENTRAL SAINT MARTINS**

EDITED BY GRAHAM ELLARD
AND JONATHAN HARVEY
ASSOCIATE EDITOR ARANTXA ECHARTE

acmestudios
SUPPORTING ARTISTS SINCE 1972

ual: university of the arts london
central saint martins

 : Double agents

black dog publishing
london uk

**Acme Studios** is England's leading affordable artists' studio developer and provider. Formed by Jonathan Harvey and David Panton in 1972 and constituted as a charitable housing association, Acme is dedicated to supporting artists in economic need through the provision of studios and accommodation.

Based in London, Acme currently manages 16 buildings (15 in London, one in Cornwall) providing high-quality studios (572 units) and work/live space (24 units). Through this resource it benefits over 700 artists each year.

Acme's Residency & Awards Programme adds to this core service of studio provision through collaboration with a range of partners, granting selected UK-based artists work/live residencies and studio awards which include rent-free studios, bursaries, professional mentoring, publishing and exhibiting opportunities. At any one time over 30 artists benefit from this support.

Acme's International Residencies Programme currently manages 22 annual London residencies on behalf of eight agencies, together with Associate Artist Residency opportunities for international artists applying directly to the organisation.

Acme is a self-sustaining organisation with a portfolio of permanent and long-term buildings. It shares its research and knowledge through a national strategic advocacy and advisory service.

**Central Saint Martins** is one of the world's leading centres for art and design education, a reputation based around the achievements of its graduates, staff and students.

Central Saint Martins was formed in 1989 following the merger of two historical London art and design colleges, St Martin's School of Art and Central School of Arts & Crafts. Founded in 1854, St Martin's School of Art focused on fine art and fashion. The Central School of Arts & Crafts was founded in 1896 and focused on a wide range of design disciplines including theatre, industrial and graphic design. In 2011 the college moved from its two main sites on Charing Cross Road and Southampton Row to an ambitious and award-winning building, designed by Stanton Williams Architects, in King's Cross, London. Central Saint Martins is one of the six colleges that form the University of the Arts London.

**Double agents** is a research project based in the Art Programme at Central Saint Martins. Founded in 2003 it is co-convened by Graham Ellard and Anne Tallentire. Other artists and curators involved in the project include Adam Chodzko, Jaki Irvine, Uriel Orlow and Lisa Panting. The project constructed a 'two-way traffic' between the art school and practicing artists through events, publications and exhibitions. With this now forming an established feature of the Art Programme, Double agents has developed larger collaborations with external partners, the principal example being its work with Acme Studios.

**The editors would like to acknowledge** the invaluable parts played by Anne Tallentire (Double agents, CSM) and Julia Lancaster (Residency and Projects Manager, Acme Studios) in the initial discussions and preparatory stages of the project. Thanks also to Jane Gibb, Research Support Manager, CSM; Brent Holder, Business Development Manager, UAL; Monica Hundal, Assistant Director of Innovation and Enterprise, CSM; and Doug Irish, KTP Regional Advisor, for their support and guidance during the KTP application process and beyond.

We would also like to thank all those associated with the ongoing management of the KTP: Jan Stringer, KTP Regional Advisor, Innovate UK; Alisdair Aldous, Enterprise Development Manager, UAL; Jill Kovacs, Projects and Communication Coordinator, Knowledge Transfer, UAL; Dani Salvadori, Director of Innovation, Business and External Relations, UAL; and Mark Anderson, External Associate Mentor, Head of European Programmes at Glasgow Caledonian University. Their support was critical to the success of the KTP.

We would like to acknowledge the invaluable input of those who contributed to the project's primary research and thus to the success of the projects that emerged: Acme Studios' artists and staff, other studio providers and CSM students who variously took part in interviews, surveys, seminars and workshops. The commissioned work of photographers Hugo Glendinning and Moz Bulbeck has added important and complementary material to the research and we are indebted to Hugo for his significant 'visual essay' and to Moz for her objective 'time-lapse' survey of studios from empty to occupied.

The support of CSM continues to be critical to the success of our ongoing collaboration and we would like to acknowledge the contributions made by Mark Dunhill, Dean of Academic Programmes; Professor Janet McDonnell, Associate Dean of Research; Alex Schady, Programme Director, Fine Art; Mick Finch, BA Fine Art Course Leader; Geoffrey Makstutis, Course Leader, BA Architecture: Spaces and Objects; and Oscar Brito, Contextual Studies Coordinator, BA Architecture: Spaces and Objects.

The development of a detailed brief for new-build affordable studios was one of the principal outputs of the project. The editors wish to acknowledge the professionalism and passion of those who delivered the studio building at High House Production Park and scrutinised and further refined and improved our brief: Matthew Essex, Head of Regeneration, Thurrock Council (responsible for capital project delivery) and the architects Tom Grieve and Hana Loftus (HAT Projects). Thanks are also due to Robin Holloway, Manager, Student Accommodation, UAL for his important input in the development of space at the Glassyard Building, which houses the CSM Associate Studio Programme, and his continuing work with us to enable this programme to expand.

The future of the ongoing collaboration between Acme Studios and CSM relies on the commitment and support of both organisations, and the editors wish wholeheartedly to thank them for their continuing belief in the value of our shared enterprise.

For their assistance in the production of this book we also thank Caroline Woodley and the contributors: Hugo Glendinning, Peter Heslip, Robert Keegan, Hana Loftus, Jan Stringer and Jeremy Till.

The Acme Studios/CSM KTP, nominated by the Arts and Humanities Research Council, was shortlisted for the Research Council UK (RCUK) Knowledge Base award—for a research council-funded partnership that has delivered outstanding benefits for its academic partner.

The Acme Studios/CSM Knowledge Transfer Partnership was supported by Innovate UK (formerly the Technology Strategy Board) and the Arts and Humanities Research Council, with additional funding from Arts Council England.

# FOREWORD
## JEREMY TILL

**What formalised the ongoing collaboration** between Central Saint Martins and Acme Studios was a Knowledge Transfer Partnership (KTP). A straightforward term that suggests knowledge can be parcelled up and passed in one direction, from expert to amateur. This form of transfer may suit certain types of instrumental knowledge, particularly those of the sciences, but sits less comfortably with the arts, which is perhaps why the KTP between CSM and Acme was the first ever to be awarded to a partnership focusing specifically on artists' practice.

Knowledge in the fine arts does not present itself in an easily transferable form; there are no equations, no toolkits, no statistical analyses and few replicable processes (in so much as art is a fundamentally interpretative act in which processes are adjusted according to the hands they pass through). This is not to say that there is no knowledge in the fine arts, of course there is, but it is often implicit and sometimes tacit within the objects and processes of art. There is now an established route of research-by-practice/practice-by-research that brings this locked-up knowledge to the surface in a discursive manner. University of the Arts London has played an important part in developing perspectives on research that are creatively productive and do not smother the contingency of artistic production under the strict laws and methods of scientific research. The Acme/CSM partnership draws on this research model. Its methods are iterative and multiple (as this book clearly shows), reflecting the area being studied. Changes in art practice and the art market mean that different models of artists' studios are required. The image of the Victorian artist in his light-washed lofty Chelsea studio is hard to banish, but is inappropriate for much contemporary practice which melds media, disciplines and working styles. The creative dialogue that the KTP engendered allowed these new models to be explored in depth, bringing together two bodies of knowledge (from academia and from an affordable artists' studio provider), with the results being more than the sum of the parts. The boundaries between art schools, external arts agencies and the cultural sector are much less marked than in other disciplines, but a vehicle such as this KTP develops those connections in an extremely productive way.

The Knowledge Transfer Partnership initiated a true partnership; both parties have specific expertise and knowledge, and the collaboration allows these not so much to be transferred as mutually exchanged. There is a degree of ambition on both sides of this exchange. For Central Saint Martins, a desire to engage with new opportunities of support for our students in their emerging practices. For Acme, the wish to contextualise and develop new and improved models of studio provision. And for both sides, there is an urgent need to address the way that art might survive in the ridiculously overheated London housing market. Where Acme could once afford to convert former factories into studios, developers now snap these up and turn them into overpriced rental housing.

These are not nice-to-know issues; they are at the very heart of what the future of art in London might be. It is no accident that a new energy in the art world is coming out of Berlin,

with its cheap and appropriate studio spaces. I look with huge admiration at the way our students negotiate the economic and spatial strictures of London, and adjust their practices accordingly, but I also worry continuously about what might happen to them afterwards. There is only so much that they can adapt to survive, and maybe that adaptation will drain their artistic identity, and with it the identity of London as a centre of creative productivity.

An informed understanding of the future of studio provision is thus central to an understanding of how art and culture might develop in this city and others. Artists' studios stand against the commodified and quantified spaces that are now enveloping us. Where the current production of space in London is completely dominated by the rules of measure and the values of the unfettered market, this study shows that space can and should be considered in other ways and measured against different values. What an artist looks for is very different from what the market generally provides; they need flexible, robust and background spaces, in contrast to the commercial world where the norm is for fixed spaces that foreground a superficial lifestyle aesthetic. In the long term the artists' studios that Acme and other organisations are producing should prove the more resilient model. This was recognised in the recent RIBA (Royal Institute of British Architects) award to Acme's High House Artists' Studios. Architects—and here I speak as one—tend to privilege refined, expensive, aesthetic over use or resilience, but here the incredible feat of teasing out a brilliant background building from a truly tiny budget was recognised, introducing an alternative value system to the awards. The research coming out of the KTP is recognised in the development of the brief for High House Artists' Studios, showing the importance of such collaborations between the university and cultural sectors.

The issues around artists' studios that the partnership addresses and which are presented in this book are crucial to the future vitality of our shared creative disciplines.

*Jeremy Till, Head of Central Saint Martins and Pro Vice-Chancellor of University of the Arts London*

# INTRODUCTION

GRAHAM ELLARD
AND JONATHAN HARVEY

*Studios for Artists: Concepts and Concrete* reports on a work in progress, an ongoing collaboration between two London-based art institutions: affordable studio provider Acme Studios and art and design college Central Saint Martins. This partnership is about exploring a range of 'concepts'; research into the form, function and future of the artist's studio is central to both the collaboration and this publication. Achieving a conceptual understanding of 'the artist's studio' however has not been an end in itself, but is seen as an essential process if 'studios for artists' are to be created to meet their changing needs. Critically then, it is also about 'concrete', about making things happen; our aim is to create sustainable programmes, which support recent art graduates, and to develop permanent, affordable, multi-unit studio buildings for the benefit of artists now and in the future.

Like any good institutional collaboration it didn't start this way, it began as a conversation between people with ideas. The Knowledge Transfer Partnership was at the centre of its development, and provided a formal structure and funding, but those first discussions began long before the KTP.

In August 2008, Graham Ellard and Anne Tallentire, as the research project Double agents, approached Acme through Julia Lancaster, Acme's Residency and Projects Manager, with an idea for a studio-based research fellowship as a partnership between CSM and Acme.[1] As the discussion broadened the plans evolved, including, in different iterations, research studentships, residencies and fellowships, but a study of the contemporary artist's studio and its changing definitions and functions was always central. Although not all these initial ideas were taken forward, each aspect of the proposal cemented a conversation driven by the importance to both organisations of 'the studio' and the needs of the students, graduates and artists they supported.

For the organisations this was a time of change, with both involved in major new developments. Acme was delivering a capital development programme of new-build artists' studios, and CSM was planning to move from its original home on Southampton Row and Charing Cross Road, where the art courses had been since 1938, then as St Martin's School of Art.

Acme's capital programme, begun in 2006, had established a pioneering model whereby permanent, high-quality and affordable studio buildings were being created in partnership with social and commercial housing developers. This programme would see Acme establish a permanent portfolio of properties and become self-sustaining by 2015. This was bucking the trend, being achieved where generally the history of affordable studios in the capital and beyond has been characterised by temporary and low-quality provision, made all the more challenging by increasing demand and exceptionally high land and property values.

For CSM, planning the move to the new King's Cross building was undertaken against a background of extraordinary pressures: reduction in central government funding and teaching budgets, the introduction of student tuition fees, increased student numbers and the recurring need, brought into sharp focus by the relocation and the design of a new art school building, to justify the use of every inch of space—workshop, teaching and, in particular, the individual student's studio space.

The idea emerged of undertaking a funded research and development project as a way of working within a formal structure to intensify the pursuit of differing but entirely complementary preoccupations. Further discussions followed at CSM with the input of colleagues regarding possible sources of funding,[2] and the first meeting around a more developed proposal and funding plan took place in November 2008.[3] After initial approaches to the Arts and Humanities Research Council, and the possibility of the project being supported as a Knowledge Transfer Fellowship, it was further refined and developed and its suitability to the objectives of a KTP became apparent.[4]

A successful application was made for a two-year KTP which, consistent with other KTPs, would focus on improving the company's product (ie Acme's studio provision). This would be supported by the "knowledge-base" partner, CSM, and achieved through the employment (by the University of the Arts London) of an Associate based at Acme full-time and jointly supervised by the partners. This first-ever KTP, with the processes of art practice at its core, would prove to be a highly-flexible vehicle which, while focusing on "product development", would also allow the partners to be responsive to other opportunities. In July 2010 the KTP team, the authors of this introduction, was established, with Graham Ellard and Jonathan Harvey, who had effectively sustained the conversation, being joined by Arantxa Echarte, who had been appointed as the Associate. Extended by six months the KTP formally ended in January 2013 but, as this publication relates, the three of us continue to work together through the establishment of an important research capacity within Acme with Arantxa as Research Officer, which also supports the ongoing collaboration between Acme and CSM.

The first three essays in this publication present our individual perspectives on what has happened during the collaboration to date. As a summary report this book doesn't intend to be exhaustive or comprehensive, and certainly doesn't include all of the primary research material produced in the course of the project. Of particular value are the recordings of 31 oral history interviews with Acme tenants, which represent artists' experiences in relation to their studios, in their own words. These interviews, along with photographic material, form the KTP project's archive and are held by and can be accessed through Acme and CSM. Taken together, our essays aim to demonstrate how the KTP became a remarkably fitting platform, which not only allowed important research to be undertaken that would prove critical to the achievement of sustainable projects and programmes but, as importantly, became the basis for how our organisations might continue to work together.

The development of an award-winning studio building, High House Artists' Studios, in Thurrock on the Thames estuary, is the subject of Acme's opening chapter, "Making It Happen". This initiative is contextualised by reference to Acme's 40-year history of providing affordable artists' accommodation, studio design development and management. An involvement in designing a stand-alone studio building in partnership with the local development corporation was in itself an exceptional opportunity, but being able to apply a greater understanding of artists' needs,

through the research emerging from the KTP, would ensure that the construction cost was extremely low and that the studios would come to represent Acme's most successful yet in meeting the diverse and changing needs of artists.

The second chapter, "The Studio as a Noun and a Verb", puts the interests of the project into a broader context of received images and definitions of the artist's studio, and the extent to which a studio can be seen to operate as both a material and immaterial space — providing a physical resource as well as a figurative place in which to think or act 'as an artist'. Representing CSM's contribution, the essay discusses how the project's design focus, dealing with the pragmatic issues of floor plans, fenestration, material specification, etc, was balanced by drawing into our discussions these immaterial aspects of the studio's importance. In doing so it aims to make a new contribution to the increasingly evident discussion of 'the studio' through its grounding of the conceptual and historical in the practical needs and interests of art students and working artists.

The third chapter, "Investigating The Studio", presents the Associate's commentary on the questions and factors driving the research, and the research processes developed by the KTP team. This essay describes how the research evolved, with the 'users' — in this case the artists — as subject, and refers to some of the methodologies implemented, such as data gathering, selecting the interviewees and applying a timeline to the photographic investigations. Questions were raised, for example, about how to respond to the extent to which the development of studio provision in the UK is being influenced by shifts in contemporary art practice (including changes in art education) and the impact of the economic recession against the continuing increase in London property values. The data included in this essay demonstrates how the research informed the principles established for the new Acme studio design and performance specifications, and for the collaborative programmes.

A central element of the KTP research was the commissioning of a visual essay by photographer Hugo Glendinning as presented in the fourth chapter, "Everything is Work: The Studio as Archive of Lived Practice". Having documented Acme's studios over a number of years, Hugo Glendinning has selected the images to be included here and writes about his approach to the commission. The choice of studios was based on the careful selection of a representative range of Acme tenants, who were also engaged in the oral history interviews referred to above. The essay provides a remarkable insight into artists and their studios in London at the beginning of the twenty-first century.

Given that the contribution made by the KTP to the development of High House Artists' Studios has been significant, further details about the studios are provided in the fifth chapter, "The Architecture of Utility", an essay by Hana Loftus, of the architects HAT Projects, which sets out their response to what was a challenging brief. The essay is also accompanied by a drawing of the scheme together with photographs of studios both empty, at the point of the building's completion, and occupied. The context in which the studios have been developed and operate is an important part of our narrative and an overview of High House Production Park, an international centre of excellence for the creative industries in Thurrock, which operates in partnership with the Royal Opera House, London; Creative & Cultural Skills, Essex; Thurrock Council; and Acme Studios, is also provided.

While the refinement of the brief for High House Artists' Studios is the principal concrete achievement of the KTP, the development of the Associate Studio Programme is very much the

product of our ongoing collaboration. The final chapter, "Future Collaborations", describes the development of this programme which so clearly expresses the shared and complementary responsibilities of the partners, specifically for the support of art graduates immediately post-college. Already established at the Glassyard Building, Stockwell Green, this is a new sustainable model and plans are already in place to expand the programme.

Other contributors to the publication are those who, in differing capacities, have both supported and closely observed the development of the KTP and our collaboration. We are grateful to Jeremy Till (Head of Central Saint Martins and Pro-Vice Chancellor University of the Arts London) for his foreword and to Jan Stringer (KTP Regional Adviser, Innovate UK), Robert Keegan (Knowledge Exchange Portfolio Manager, AHRC) and Peter Heslip (Director, Visual Arts and London, Arts Council England) for their afterwords. Their commentaries broaden the context in which our activities are presented and provide useful assessments of what we have been doing and what has been achieved.

The purpose of this publication is not just to report what has been happening. Its true value, which only time can judge, is in the sharing of the models we have developed. Both the form of our collaboration and its outputs are genuinely transferable and it is our hope that they may prove useful to others. Robert Keegan's insightful essay draws a distinction between the concept of "knowledge transfer" and "knowledge exchange" and it is "exchange" and "co-production" which is at the heart of our partnership. It has been founded in the spirit of mutual respect and a willingness to be challenged, and we hope this publication communicates our shared commitment and continuing enthusiasm for what lies ahead.

*Arantxa Echarte (Research Officer, Acme Studios), Graham Ellard (Professor of Fine Art, Central Saint Martins) and Jonathan Harvey (Chief Executive, Acme Studios).*

Notes

1   These initial discussions were based on an idea for a scheme providing a selected graduate with a free studio for one year, a programme to be repeated over three years. In parallel a PhD student would pursue research into the experience of recent graduates and their needs in terms of studio provision.

2   Monica Hundal, Assistant Director of Innovation and Enterprise, and Jane Gibb, Research Officer, CSM. Later in the process of identifying the potential for the project as a KTP, and in the application process, Brent Holder played a key role. Doug Irish was the project's 'mentor' from Innovate UK and was a great supporter. UAL's Enterprise Development Manager, Alisdair Aldous worked closely with us during the project and his input was enormously valuable.

3   With Professor Anne Tallentire, Julia Lancaster and Mark Dunhill, Dean of the School of Art (now the Art Programme) at CSM.

4   Work began on the application in June 2009, led by Graham Ellard and Jonathan Harvey. It was submitted in November 2009, with the funding agreed and the project formally launched in January 2010. Arantxa Echarte was appointed as Associate in April 2010 and the KTP team started working together from July 2010.

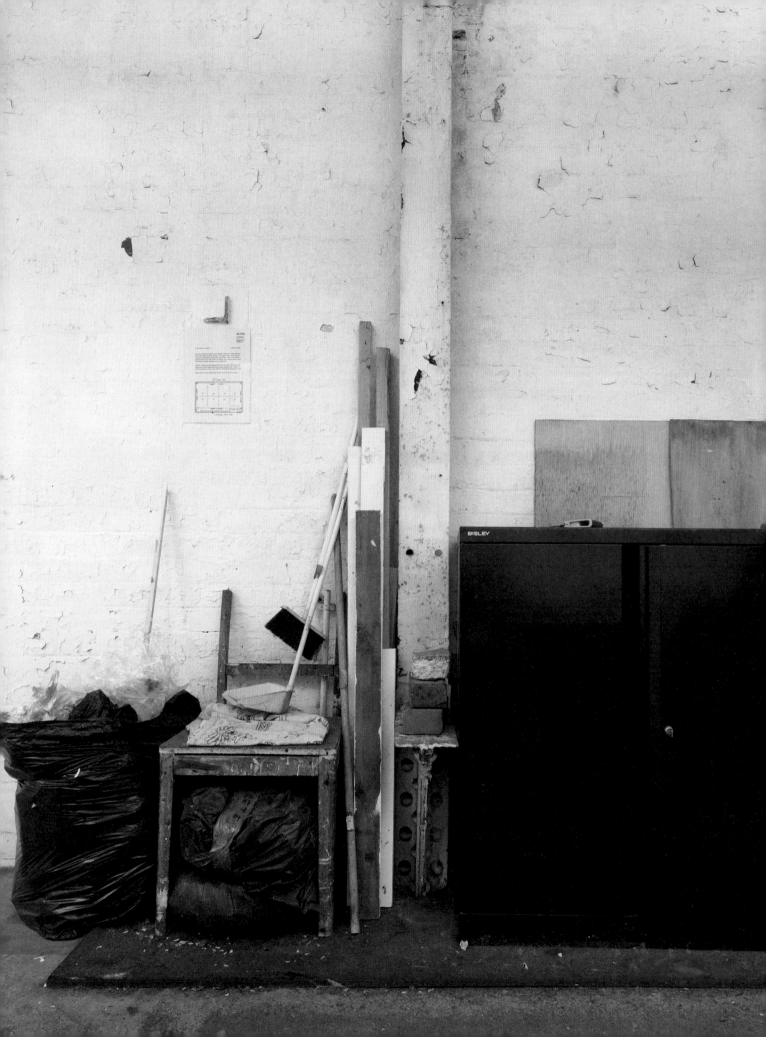

# MAKING IT HAPPEN

JONATHAN HARVEY

1

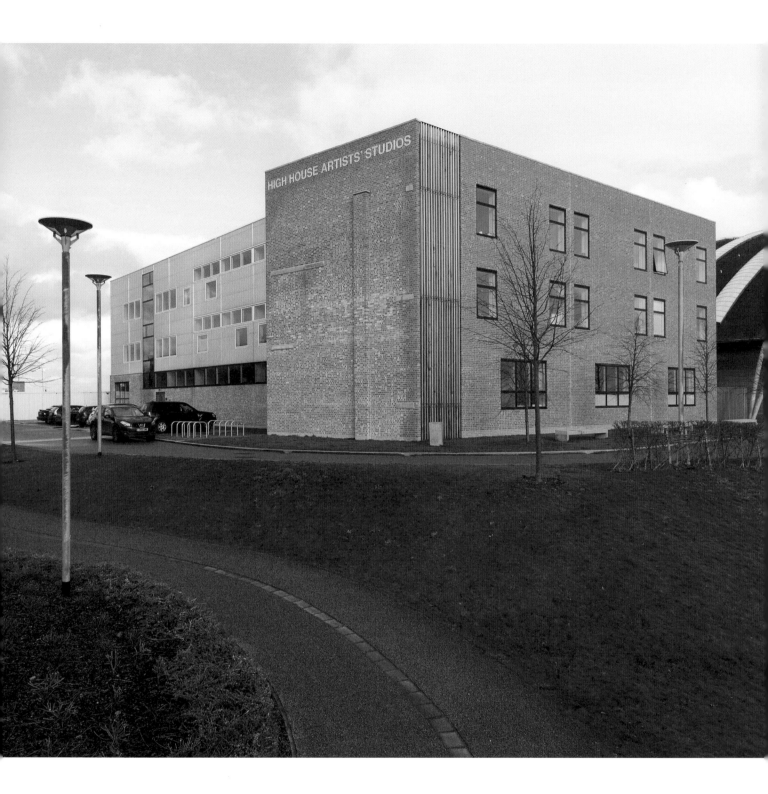

High House Artists' Studios  RM19
Photograph: Hugo Glendinning, 2013

**In July 2013** a new artists' studio building opened at High House Production Park, Purfleet, Essex, providing 39 studios and four work/live units arranged over three floors. It could be said that, notwithstanding over forty years of providing thousands of artists with affordable living and studio space in hundreds of buildings, this was Acme Studios' first studio building. By 'first' I mean that everything that had gone before—the use of short-life housing, the conversion of redundant factories, and new-build studios embedded within mixed-use developments—had not taken the form of a stand-alone building, purpose-designed and built from scratch. This opportunity was both exceptional and challenging—there could be no excuses. Failings in the building's design and subsequent performance could not be conveniently attached to the limitations of working with an existing physical structure or attributed to the constraints of a brief for a developer's mixed-use project that had other design agendas to address.

It is generally recognised that affordable studio provision in the UK has been artist-led, with buildings developed and managed either by groups of artists or organisations which are artist-centred. The studio block at High House represents another 'first' in that a development company, Thurrock Thames Gateway Development Corporation (TTGDC) delivered it.[1] The studio building at High House represents a stage in the continuing realisation of a remarkable vision to establish, in the Thames Gateway, a world-class centre of excellence for the cultural and creative industries. This unlikely site and setting, an abandoned 14-acre farm overlooking the estuary just upstream from the Queen Elizabeth II Bridge at the Dartford-Thurrock crossing, had already attracted the Royal Opera House who opened their purpose-built Production Workshop in December 2010, followed by Creative & Cultural Skills whose Backstage Centre started operating in early 2013. The project had been driven by a long-standing dialogue between Arts Council England (ACE), The East of England Development Agency, TTGDC, Thurrock Council and with those who would come to occupy the Park: the Royal Opera House, Creative & Cultural Skills and Acme Studios. In 2007 the concept was formally agreed, the site identified and the "anchor tenant" partner, the Royal Opera House, secured. The partners saw not only the potential, but also the need to pursue an ambitious project which would act as a catalyst for wider sustainable regeneration.

Acme's involvement in the project began in 2007 when we were commissioned by ACE to undertake a "demand study" for artists' studios in the Park. The interest expressed by artists was sufficiently encouraging for a studio building to be included in TTGDC's overall vision and master plan. In 2010 we were commissioned to undertake a detailed feasibility study, which included an outline design of the building enabling us to carry out capital and revenue cost modelling. This effectively created the blueprint for the project. Once capital funding had been identified we worked with TTGDC (the principal client) to appoint the architectural practice HAT Projects and were then fully involved (as end user) in the design development process. In October 2012 construction work began and the building was completed for occupation in July 2013, with Acme taking a 25-year risk-sharing lease from High House Production Park Ltd.[2] In April 2014 the building became fully let.

**Design development and the partnership with Central Saint Martins**
There are two threads to the history of the development of the building's design. The first is the 40-year history of Acme and the accumulation and refinement of a largely self-acquired detailed design and performance specification. The second is the coincidence of this opportunity 'to

design from scratch' with the evolving partnership with Central Saint Martins (CSM) which became formalised through a two-year Knowledge Transfer Partnership (KTP). The following, which focuses on High House Artists' Studios, is an example of how the partnership with CSM has so effectively supported Acme's recent developments, but, as this publication makes clear, it is not the only example.

The development of Acme's designs and specifications for artists' space has always been informed by anecdotal feedback from users, supported by considerable building-management experience. It's not that we haven't been listening—the genesis, culture and focus of the organisation has always ensured an informed and acute understanding of artists' needs—but what distinguishes the production of our 'new' design brief is the application of formal research methodologies through the KTP, including data analysis and direct feedback from artists.

The new building is a powerful and practical manifestation of the most recent iteration of Acme's design brief. The coincidence of theoretical design development and a live project enabled this brief to be scrutinised and further refined in practice by Acme, TTGDC and HAT Projects. It is axiomatic that a building offering affordable rents should be achieved at low cost; economic design and build is at the heart of this narrative, and the remarkable construction cost of £78/ft$^2$ (£836/m$^2$) creates an important model for future sustainable developments.[3] What also emerges from this economic imperative is, by default, a pleasing aesthetic, which has found its fullest and most eloquent expression in HAT Projects' approach to the building at High House.

Importantly, as discussed elsewhere in this publication, the collaboration between Acme and CSM, formalised through the KTP, also established for Acme a new way of working—a formal structure for critical and creative reflection, resourced by a research capability—which has made an important contribution to the building's design and continues to support the organisation's strategic planning more generally. The studio development at the Park needs to be seen in the context of the other key outputs of the KTP, importantly the continuing collaboration with CSM where a shared interest in 'the studio', seen from different but complementary perspectives, and a commitment to helping recent graduates, is establishing new and sustainable models of support.

What follows is an attempt to chart the evolution of Acme's design principles for the creation of affordable artists' studios in multi-unit buildings through an analysis of key models, including the use of short-life municipal housing stock, the conversion of ex-industrial buildings, the construction of work/live space and of new-build studios within large-scale, mixed-use developments. This provides the "audit trail" leading to the recent development at High House, produced by partners with shared objectives ie the achievement of self-sustaining, permanent, high-quality and, most importantly, affordable artists' studios.

The audit-trail will necessarily reveal how the underlying imperatives which informed the organisation's beginnings continue to drive the development of the studio model, namely: affordability, permanency, flexibility and fitness-for-purpose. It is also important to acknowledge that elements of the environment in which we operate have not changed over time: the lack of affordable, secure and good quality studio space for artists, and the attendant constant and increasing demand, the lack of consistency in the strategic support to address this situation from local or national funding, or from governmental agencies, and, from a design perspective, the challenge of designing for the unpredictable as the nature of contemporary art practice, and the materials and technologies employed, continues to evolve.[4]

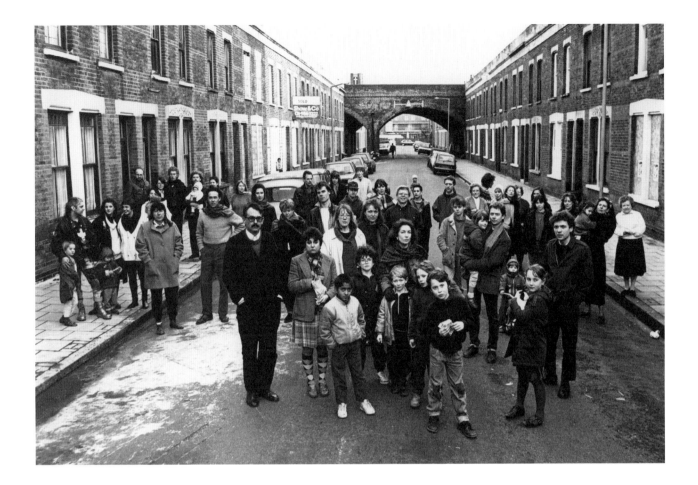

### Acme's beginnings in East London, 1972

Acme began as the chance meeting of a huge demand by artists for cheap living and working space with the untapped supply of street after street of short-life municipal housing stock destined for demolition. It acquired a governance model, as a means to unlock this supply, of a housing association with a principal charitable purpose—the provision of "accommodation and associated amenities" for those "in necessitous circumstances upon terms appropriate to their means"—which perfectly matched the situation on the ground and the aspirations of this graduate-led enterprise. This was a governance model which, accidentally rather than by design, also ensured that the organisation's work, resulting in its eventual success as a self-sustaining entity, would focus almost exclusively on 'poor artists' and 'cheap space', without the distraction of other public benefit agendas associated with audiences.

The temporary use of municipal housing stock programmed for demolition—was to become Acme's first and principal means of helping artists, with hundreds of properties from a range of sources becoming a remarkably active and well-used resource. The property supply faded at the beginning of the 1990s and by December 1997 the number of houses managed by Acme had reduced to 50, and now to no more than a handful. But in some cases the redevelopment schemes that had destined the houses for demolition were cancelled and many artists had the opportunity to buy their homes as secure tenants and at a substantial discount.

Beck Road  E8
Photograph: Edward Woodman, 1988

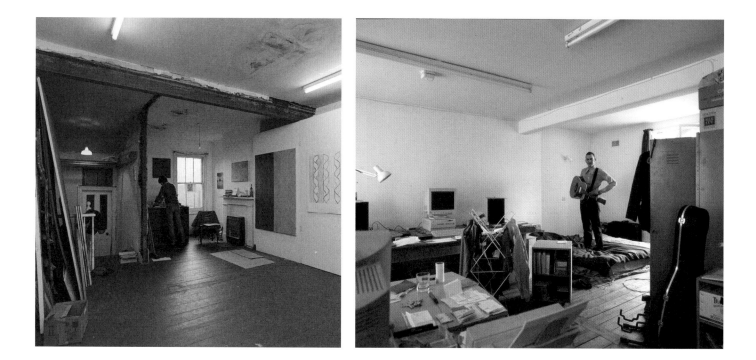

The combination of living and working space enabled two things to happen. Firstly, for many artists, then as now, it was simply not possible to afford a London studio in addition to somewhere to live—but the ultra-low rent of a short-life house made such space affordable. Secondly, the approach to the use of this property, in contradiction to the conventional concern to improve and extend the life of a resource, was in anticipation of these houses' demolition. And this provided an opportunity. In a small terraced house destined for the bulldozers, artists could remove internal walls and expose roof voids to reconfigure the space to one that was finely tuned, often with great ingenuity given limited means, to their own creative and domestic requirements. In return for this opportunity the artist had to be 'hands-on'—the early days of Acme were very much about 'self-help'—and reconciled to the fact that this was only a temporary solution, with the actual date of 'hand-back' often imminent or uncertain.

While there had been some external financial support, in the form of small studio conversion grants from the Arts Council, to maintain the lowest possible rents it was necessary always to seek and apply economic solutions to repair and conversion. This became second-nature, engrained in the organisation's approach to everything it did and a discipline maintained to this day. The remarkably low construction cost achieved for the High House Artists' Studios chimes well with that early founding necessity and principle.

The other experience which became absorbed, though perhaps not formally expressed or acknowledged, was the extraordinary range of approaches and interpretations which artists brought to their use of short-life housing, driven both by their varying practices but also by where the dividing line, in practical terms, would be drawn, in some cases if at all, between their working and domestic lives. This acquired knowledge would be returned to when developing "work/live" space at the Fire Station building in Poplar, London E14 in 1996, which subsequently became the model for further work/live developments, including at High House.[5]

Beck Road E8
Sandra Porter in her Acme house
Photograph: Edward Woodman, 1984

Fire Station E14
Martin Creed in his work/live unit
Photograph: Hugo Glendinning, 1999

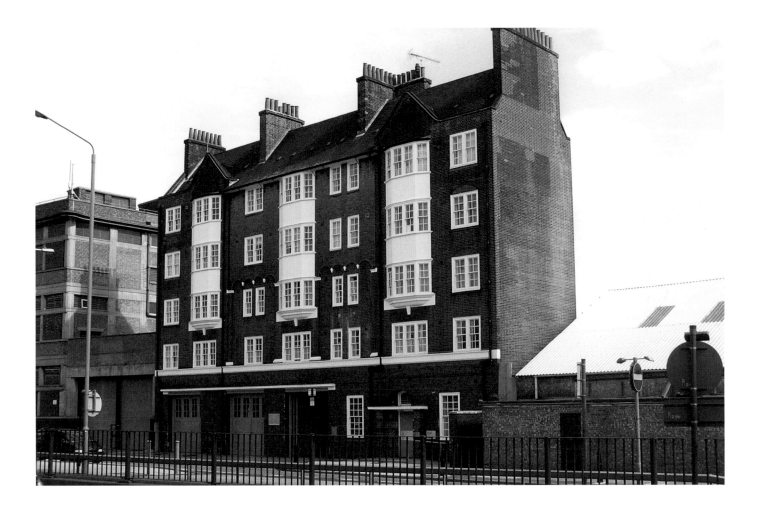

### Use of ex-industrial space

Whilst Acme's use of short-life housing stock was unprecedented and saw Acme artists as the first to move into the heart of East London, the use of redundant industrial buildings and warehouses converted to multi-unit studio blocks had, notably, been pioneered in London by SPACE in 1967 at St Katharine Dock, close to Tower Bridge. With deindustrialisation and the move of the docks downstream, opportunities arose for buildings to be temporarily used and available at low rents. This use also coincided with artists' requirements for larger working spaces given that many were now working on a scale that could not be accommodated by a studio at home. Subsequently this became the standard model, still in operation today, with many hundreds of buildings up and down the country being converted in this way. The problem remains however that very little of this property is permanent and much, because of being, by necessity, economically modified, is poor in quality, energy-efficiency and accessibility.

Acme's first significant foray into developing non-residential studio space was at 52 Acre Lane, Brixton in 1976. Initially negotiated by artist Richard Deacon but passed to Acme to develop and manage, the site, which had been used for meat processing, was a collection of large single-storey sheds with a larger two-storey building at the rear. This was not typical of what was to follow, but it represented an important object lesson in how to use every square

Fire Station  E14
Photograph: Acme, 1999

inch of available space. Apart from necessary basic refurbishments the site essentially remained as it was without larger spaces being sub-divided. The single-storey sheds proved to be very well suited to Richard Deacon and a number of other now significant sculptors, including Grenville Davey, Charles Hewlings and Bill Woodrow. The large refrigeration room became the Cold Storage recording studios, home to musician and producer David Cunningham and experimental rock band This Heat, and even a space under the stairs became a darkroom. It seemed that the most unlikely corner would suit the requirements of a particular artist's practice, and maximising lettable space, and thus rental income, helped keep rents low; an obvious and fundamental principle of affordable studio design.

The allocation of the 'given' spaces at Acre Lane, which was handed back for redevelopment in 1996, was determined by the nature of each artist's practice, how much they could afford and by an almost universal wish to have a private rather than a shared space. This strong expression of the need for self-contained space that affords both privacy and security has become central to everything that has followed.

Factories taken on and converted by Acme which would explicitly define the layout of the new studios at High House (and elsewhere) were those at Orsman Road, N1 (1983), Carpenters Road, E15 (1985–2001), Childers Street, SE8 (1990) and Copperfield Road, E3 (1992). These buildings (for the manufacture respectively of cigarettes, cosmetics, ships' propellers and pens), generally of three- or four-storeys with greater ceiling heights at ground-floor level, are rectangular with a width which allows, through the provision of generous glazing, good daylight throughout the open-plan floors. Given the expressed requirement of artists to have their own self-contained studios, the most efficient way of achieving this is to run a corridor centrally along the length of each floor

Acre Lane SW2
Photograph: John Riddy, 1990

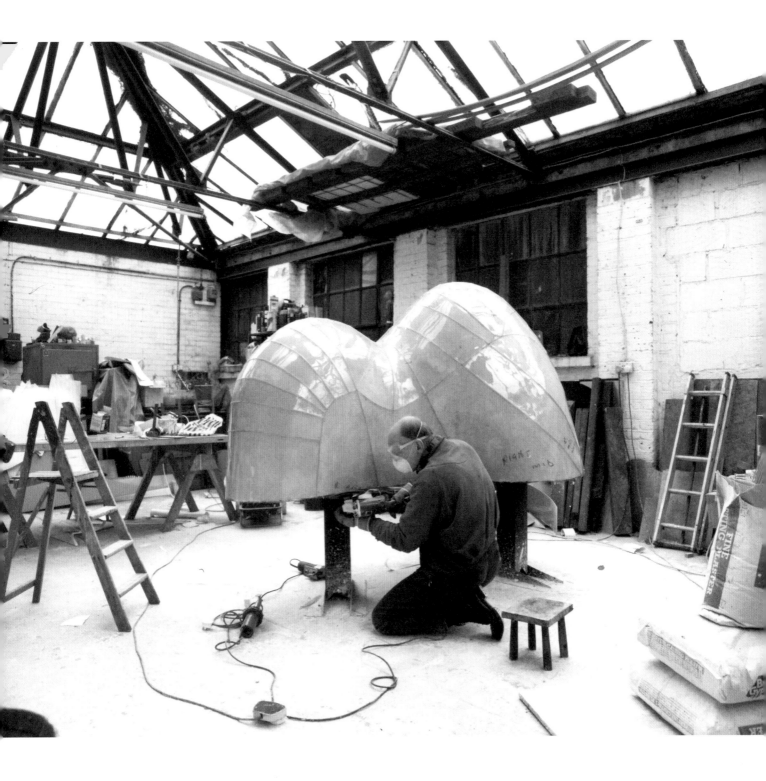

Acre Lane SW2
Richard Deacon in his studio
Photograph: John Riddy, 1989

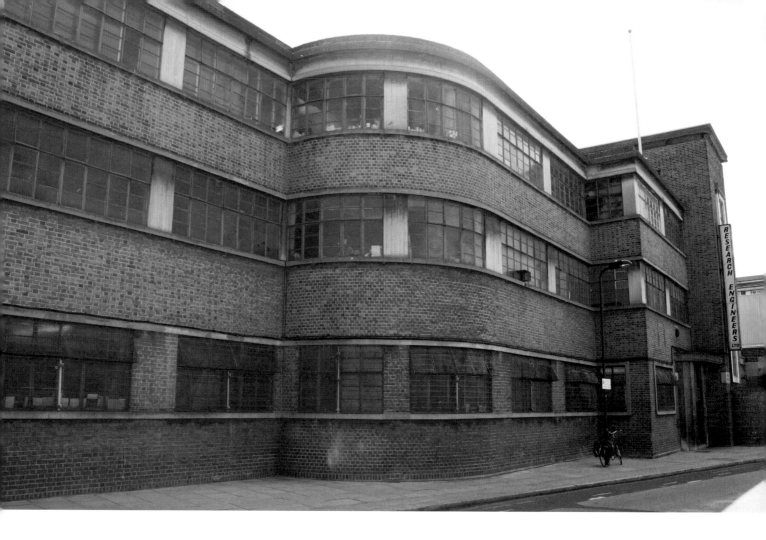

and then to laterally sub-divide with the width of each unit being defined by where the external glazing falls. In this way both useable floor area and daylight are maximised.

What actually happens within each studio is ultimately unpredictable, thus what comes into a studio building as 'material' and, once transformed, comes out as 'the work' is similarly so. There is a need therefore to ensure that large items can enter and leave and, with existing buildings, it is important to ensure that what can pass through a generous ex-factory entrance can also pass through corridors, lifts and stairs and finally through each studio door. This is a simple but essential requirement now embedded as a design principle.

With the conversion of buildings, the existing fenestration defines where sub-divisions fall and subsequently unit size. For most artists however, the size of their studio is more often determined by their pocket than by their practice. There is always therefore a concern to create a range of sizes. Since the demand for studio space at High House was largely unknown due to the specifics of its location (demand studies suggested interest but with no history of studio space in the area it was highly speculative and, ultimately, demand is evidenced by actual lettings) it was thus important to provide for a greater range than elsewhere where demand (in East and South East London) for our new schemes routinely results in near-100 per cent sustained occupation within a month of opening. The range at High House of between 130ft$^2$ (12m$^2$) and 1,600ft$^2$ (149m$^2$) is much greater than at our other sites. Given the focus at the Park on 'production' there was an opportunity to create extra-large studios on the ground floor of up to 1,600ft$^2$ specifically for those artists making sculpture on a large scale. Because demand was uncertain it was important

Orsman Road N1
Photograph: John Riddy, 1983

to "future-proof" the building and an allowance was made for simple and economic sub-division of the largest studios and for the smallest to be combined. This included, for example, the specification of walls for the smallest studios which could be simply removed to create larger studios by 'collapsing' two or more together, and for the power and lighting supply and fittings to be easily separated if one of the largest spaces became sub-divided into up to four smaller units.

### New-build as part of larger mixed-use developments: pros and cons

In 2006, through a partnership with Barratt Homes in Peckham, SE15, we were able to apply our accumulated knowledge of studio development and management to a new-build project for the first time. Barratt had sought planning consent for a development of private and affordable residential apartments, but given the previous employment use of the site the local authority, Southwark, rejected the application, requiring jobs to be secured as part of the new scheme. We had already started a conversation with Barratt, who had been encouraged to work with us by the London Borough of Newham—this was following the hand-back for redevelopment of our Carpenters Road site in 2001, which resulted in the loss of affordable studio space in the borough. Barratt needed to react quickly to the planning refusal and saw us as an expedient way to salvage their scheme. They asked us to provide the employment element by introducing affordable artists' studios. We agreed and planning consent was subsequently granted. For the first time we were working with an architect, albeit on contract to the developer (all previous conversions involved specialist sub-contractors with Acme as project manager) and we assembled our brief in the form of a detailed design and performance specification. The agreement with Barratt was that they would build to our specification and we would pay them a sum based on measured as-built lettable floor area at a rate roughly half that of the development

Orsman Road N1
Prior to conversion
Photograph: Acme, 1982

cost. The purchase price (of acquiring a long-term leasehold interest) was low enough that even if 100 per cent of it was raised as a loan, affordable rents would cover the cost of servicing the repayments, the direct cost of running the building, and generate a small surplus. Once the initial loan was repaid the building would then generate a larger surplus which could be applied to future developments and projects.

The building, the Galleria, opened in 2006. It consists of 50 self-contained studios ranging from 260ft$^2$ (24m$^2$) to 500ft$^2$ (46m$^2$) over five floors and forms one block of the larger residential development. Whilst our brief would deliver studio units similar to those in converted buildings, but with notable improvements to thermal and acoustic insulation and in a building which had to meet current accessibility standards, there were two elements which we considered non-negotiable. The first was our requirement to achieve 3m minimum ceiling heights, the second to be able to define the fenestration. In many of our converted factories ceiling heights of at least 3m would be standard. Given that the entrance to our studio block was shared with the affordable residential units this involved a shared lift serving, on one side, our studios and, on the other, residential units where the ceiling heights were 2.6m.

We also needed to be involved for the first time in defining our requirements for the external elevations, in particular, as noted above, with regard to the fenestration. Our approach, in order to maximise clear working wall areas (again a fundamental design principle) and daylight, was to provide two types of window. The first: a clerestory window running at the top and along the full length of the external wall, allowing for an unfettered working wall below. The second: a vertical window to one side, providing a view and therefore a sense of location. This works well at the

Galleria SE15
Photograph: Acme, 2006

Matchmakers Wharf E9
Photograph: Morley Von Stern, 2012

Galleria and was embraced at High House with adjustments for different studio unit sizes, views and aspects.

Our pioneering work with Barratt to achieve high-quality, purpose-designed and purpose-built and, importantly, permanent affordable studios, through what has become known as the "planning-gain" process, has continued.[6] The projects based on the Galleria model that have followed are: Leven Road, E14, 21 studios in partnership with Swan Housing Group (2009); Harrow Road, NW10, 12 studios in partnership with Catalyst Housing Group (2010); Matchmakers Wharf, E9, 49 studios in partnership with Telford Homes Plc (2012); the Glassyard, SW9, 24 studios in partnership with Spiritbond (2013); and Warton House, E15, 24 studios in partnership with Genesis Housing Group (2014).[7]

Each project is different, in some cases being initiated and driven by the housing developer (both social and commercial) in partnership with Acme, or by the local authority or development corporation. In all cases (except for the Galleria) the provision of affordable artists' studios is a condition of planning formalised through a Section 106 agreement.[8] This planning condition ensures that affordable studio provision is secured permanently and, although the drafting of these agreements will vary, the 'affordable' rent will be referenced by comparison with that of an open-market rent for physically-comparable workspace.

Each of the sites for these projects has brought its own challenges and the way in which the studio component is embedded in the larger mixed-residential and commercial scheme has varied considerably. This has led to compromises in external treatment, especially fenestration, where our requirements have had to defer to other considerations, often to do with their location but also, in one case, driven by the appearance of the building from a marketing and sales perspective. At High House there were no such compromises; this was a stand-alone building with a single function, that of working space for artists, both studio and work/live.

### "Social performance"

Early on in the development of the vision for High House Production Park, after we had completed the initial demand study, we were asked, for master-planning purposes, to suggest a size for the artists' studio block. Our experience told us that while there is a clear economy of scale in terms of construction and subsequent running costs, it is difficult for a sense of community to develop in a building of much more than 50 self-contained units. We therefore suggested a building of between 40 and 50 units with an average unit size of 350ft$^2$ (33m$^2$) to 400ft$^2$ (37m$^2$) and this proposal achieved outline planning consent as part of the larger exercise for the whole Park.

As discussed above, artists' requirement for private self-contained space would tend to limit the amount of social exchange within a studio building. In this building we avoided the temptation to include communally-used space or shared facilities. Such uses reduce affordability because they do not generate income, but do have to be resourced and managed, thus ultimately increasing the rent artists have to pay. The effect of this, given that the standard Acme building model is a collection of private self-contained studios, is that the "social-performance" of a building (the extent to which artists will come into contact and interact with each other, unless opting to share a space) will be an accident of each building's layout unless it is given specific consideration. At High House careful thought has been given to engendering a sense of common professional purpose, through artists being aware of each other's presence without compromising the privacy that they require. One function of shared wash-up rooms (in

a building where most studios tend not to have their own sinks) is that they can function socially as the 'village pump'.

The design principles which have evolved and which have been applied to the new studios at High House discussed here—economic build, flexibility to accommodate the unpredictable, maximising lettable space, enhancing a sense of common professional purpose without eroding privacy, good ceiling heights, maximising working wall areas and daylight, and future-proofing—are just some of the elements which have been under consideration. Other aspects relating to a building's performance, including wall and floor loadings, acoustic and thermal insulation, heating strategies etc, we have been able to explore in more detail than before. Within this is a set of very detailed specifications. Importantly the research undertaken, in partnership with Central Saint Martins, enabled all to be challenged, thus fine tuning what we could contribute as the 'brief'. The commitment and passion of the architects, the project delivery expertise of the client, and our own four decades of hard-won development and management experience, came together as a creative collaboration which took on this brief and achieved a building that sets a new standard in affordable studio design.

But we will only know how well the High House Artists' Studios perform in practice through direct feedback from users. The development of a comprehensive tenant survey, a further outcome of the Knowledge Transfer Partnership with Central Saint Martins, will ensure that this is captured to inform the design and management of our buildings and services in the future.

Notes

1   Thurrock Thames Gateway Development Corporation was merged into Thurrock Council on 1 April 2012, and the corporation was formally abolished on 31 October 2012.
2   High House Production Park Ltd, which operates the Park, was formed in 2008 as a wholly-owned subsidiary of TTGDC. Subsequently, with revised exclusively charitable purposes, the company achieved charity registration in January 2012.
3   From previous experience we would have anticipated a build cost of between £100/ft² (£1,071/m²) and £120/ft² (£1,286/m²).
4   Our studio waiting list represents live demand with artists required to renew/update their registration annually. In March 2007, 470 artists were registered on the waiting list. By March 2014 the number had increased to 1,496.
5   Our choice of the term "work/live" was carefully made to distinguish our studios, which include ancillary living space, from so-called "live/work" schemes, which in many cases are an abuse of the planning system whereby developers achieve residential status, and thereby values, but where the employment element is not maintained and developments drift into purely residential use.

6   Put simply, what we mean by "planning gain" is where, through the partnership, Acme and the local authority secure employment use in the form of sustainable affordable artists' studio space and the developer achieves planning for their development—in effect all parties 'gain' from the planning consent.
7   The first four or these six projects formed a capital development programme which was part-funded by a capital lottery grant of £2 million secured from Arts Council England.
8   A Section 106 agreement is a planning obligation under Section 106 of the Town and Country Planning Act 1990 and is a mechanism that makes a development acceptable in planning terms. These agreements are focused on site-specific mitigation of the impact of developments and are often referred to as "developer contributions". The common uses are to secure affordable housing or financial contributions to infrastructure improvements, and exceptionally, as with the cases cited above, to secure affordable artists' studio space.

High House Artists' Studios  RM19
Phillip Melling's studio
Photograph: Hugo Glendinning, 2014

# THE STUDIO AS A NOUN AND A VERB[1]

## GRAHAM ELLARD

**2**

**In recent years** the artist's studio has been the subject of great scrutiny. In Europe and the United States the literature on the topic has grown dramatically and now includes critical studies such as *Hiding Making—Showing Creation: The Studio from Turner to Tacita Dean*, 2014; *The Transdisciplinary Studio*, 2012; and *The Studio Reader: On the Space of Artists*, 2010. Other notable titles include the collection *The Fall of the Studio: Artists at Work*, 2009, and, simply, *The Studio*, 2006, which was produced to accompany an exhibition of the same name at The Hugh Lane, in Dublin, where the relocated Francis Bacon Studio is housed.[2] Before this explosion of interest, there was very little published with the studio, rather than the artist or the work, as its central focus.

The art school too has, of late, become the subject of debate amongst artists and theorists. This has been prompted not only by significant changes in state education in the UK as a whole (and perhaps the introduction of tuition fees in particular), but also by the so-called "educational turn" in art, or that of institutional critique. In effect the art school or academy being held up for question or direct challenge coincides with the emergence of initiatives seeking to create alternatives to what is seen by some to be overly institutionalised, unaffordable, monetised or commodified forms of education.

For some the move of Central Saint Martins from its original home on Charing Cross Road and Southampton Row to a new building at King's Cross provided a focus for this debate—seen as a model of the transition from (or betrayal of) a golden age of the purpose-built art school to an impoverished and sanitised contemporary imitation. A building mustn't be mistaken for a college, but as someone who has taught at both sites I was at first very sceptical about the move. I think, however, that neither depiction is actually true. For the Fine Art courses, Charing Cross Road provided studio space that was both very good and very bad (too cold to use in the winter and prone to flooding when it rained), workshops which were well equipped but incredibly cramped in basement spaces (fitted, as they had to be, into the existing fabric of a building designed in 1938 and a few adjacent annexes) and as for the location—it was great for coffee and a big bookshop (and up until recently a film lab) but Soho hasn't really been the Soho of myth and legend for a long time.

The question for many CSM staff wasn't why should we move out but why had the building been allowed, over at least ten years, to decline so dramatically—to the point where moving seemed to be the only option. The move did mean a reduction in space for everyone, and students on the Fine Art courses felt this perhaps more than most due to the nature of established practices, framed by the exclusive personal studio space. And this reduction remains a fact we can't ignore. At the same time, it needs to be recognised that the issue isn't quite as simple as that, since the quality of the studio spaces that the new purpose-built building at King's Cross provides, and the scale and standard of the workshops, is a great improvement (not to mention the standard, extent and dynamism of the communal spaces, thoroughfares and lecture theatres). So there were losses, but also some gains. What can be debated are the issues around what has been prioritised in the process of such a transition, what continues to be developed and improved, and what might next be deemed important and, on that basis, which way the final analysis goes.

Of course this particular move took place against a backdrop of extraordinary external pressures—reductions in funding to higher education from central government, tuition fees, increased student numbers and reduced teaching budgets. And the ongoing pressures that CSM now faces, along with every other art school in the country, leads to a constant need to

justify the use of space—workshop, teaching and (perhaps unique to art) individual student's studio space—whether used in an ambitious, regular, idiosyncratic or ad hoc fashion. One of the key effects of those pressures is a reassessment of the automatic and unconditional 'allocation' of space to each student for the duration of the course. This is a central component of what is generally seen as the exemplary art school environment—as its gold standard against which any course could be judged.

The automatic and unconditional provision of allocated space for every student is not something that CSM has been able to maintain absolutely. While the challenges that the School of Art (now the Art Programme) attempted to address were not of its own making, it is important to acknowledge that as a model the studio should not for some reason be immune to cross-examination and justification—the questioning of that apparently central tenet has admittedly been prompted by necessity, but that questioning is desirable. It is surely worth asking if this received model is the most relevant and productive use of our most valuable resource, at this moment in time, in contemporary practice. Factor in also the numerous and different uses of space—temporary, collaborative, site-specific or by project—as well as the widespread production of single-screen moving image work, for example. These activities make use of a variety of spaces, from edit suites and recording studios to location shooting and public space, and so the question of use, allocation or deployment becomes still more complex.

To be clear, I am not an apologist for the pressures CSM has had to respond to, nor am I making a case that its provision of dedicated studio space is unimportant or unnecessary—quite the opposite, I think it is so important that it deserves proper consideration. Rather, I am asking how are we defining that space and crucially its 'use'. What larger environment is the studio a part of? What practice is it intended to support? How can it best do that? These are questions raised in the interest of properly enabling students and preparing them to operate, in whatever capacity they aspire to, after their graduation.

The response CSM has made to these challenges means that many of the studios now work on the basis of need and demonstrable use—the nature of practice necessitates a space, but it is not, for every student, a default provision. Across the programme the majority of students do still have their 'own' space. But an open plan approach, where students work in very cooperative, flexible and contingent ways is used widely, with individuals establishing a base if and when needed, and then expanding or contracting according to their activity.

Both of these debates, reflected in the renewed interest in the artist's studio and the state of art education in the UK, are subjects that art schools themselves have engaged with. At CSM this took place through the "What's the Point of Art School?" series of events, and is present throughout its collaboration with Acme Studios.[3] Concepts and articulations of both the art school and the artist's studio are bound up in a spectrum of idealised, nostalgic or received ideas of what either should be, or once was. The contemporary studios pictured in some of the more lavishly illustrated books on the subject are as romanticised as any nineteenth-century rendering of the garret or the salon as an insight into the workings of artistic genius.[4] In a similar vein many debates about 'the state of art schools today' make reference to a period in which art education was apparently free of all the problems currently faced. I'm not sure such a time has actually ever existed—different undoubtedly and in some areas better resourced, but ideal? My own experience as an art student during the early 1980s was of a culture still freeing itself from an undemanding, indifferent, paternalistic and conservative tradition, but the idealised image

remains nonetheless. Some default assumptions have been (and have had to be) re-thought and considered anew, and many of these revolve around the role of the studio, and how it can best be understood, and provided, in an art school environment.

It is an understanding of the complex landscape of the art school, student activity and their use of the studio today that CSM has brought to the project with Acme—to collaboratively consider how the provision of space might best meet the needs of artists in a contemporary context. For CSM, the key issue in the work with Acme has been envisaging the immediate priorities of students on graduating and how their educational experience prepares them for the realities and vicissitudes of practice in London and other contexts beyond academia.

This has led us to ask questions of the received image of the studio, both entirely understood at a general level, but also subject to real complexity, contradiction and confusion at a specific level. Despite enormous shifts in the way artists practice, the vision of the studio remains largely unchanged and is taken to be, for example, typically exclusive and private. The two-year project with Acme has allowed us to look very closely at those general assumptions: the specifics of material and immaterial functions; the historical 'received' model, and departures from it; and how meaningful (or not) this is for students in their perception of their needs on graduation. The numerous aspects of the collaboration between Acme and CSM are described throughout this book. This essay concentrates on parts of the research undertaken through a series of seminars and workshops with undergraduate and postgraduate students at CSM, and the ideas that were presented and developed in those discussions. It should be pointed out at the start that the project was not primarily concerned with the 'single-user' stand-alone artist's studio, which despite being the typical form presented in much of the literature is far from typical in reality. The great majority of artists in London work in studios provided by studio organisations, usually artist-led, and generally based in large multi-user studio buildings. This is the predominant model and by focusing on it the research questions aimed to have the broadest significance, and the potential for real impact on the largest section of the artist "community".

The project began with the fundamental question of what a studio is, or might be. We speculatively proposed that an artist's studio is: "a workshop; a laboratory; a study; a storage facility; an office; a desktop; an exhibition space; vital; desirable; a luxury; unnecessary; out-moded; temporary; permanent; large; secure; nearby; private; sociable." Importantly we asked not only "What is the studio now?" but also "What might it be in the future?" and "How can such a thing be designed and provided?" Once we began to ask those questions in relation to design it became clear that the studio is not simply a building type. Just as the word "house" has different connotations to the word "home" the studio is loaded with meaning and significance beyond literal spatial description. Furthermore, perhaps it's not a type of space at all, but a type of use—it's possible that, through such a specific use, any space (bedroom, kitchen, table top, street corner) could be designated as, and operate as, "a studio".

It 'is' possible to think of the studio as an entirely practical place—for all the material activities of making things—such as a workshop, in which, typically, things already conceived of can be executed. And that undoubtedly holds absolutely true—the central activities of much studio use are the direct processes of making. But that isn't the whole story, or the only story. Not least of all because very few artists' studios will contain all the tools or equipment needed to make the work, and certainly very few students' spaces will. As a result, we must see it as a place that also generates plans to make, rather than just executing them. It can predict or prompt the

initiation or possibility of an activity, and how we might think of a way towards it.[5] And it's this characterisation that tells us why the argument about space that absolutely ties the need for a studio solely to material processes is missing the point of what a studio is, or does.

If we recognise this generative role, then we must ask what other 'immaterial' functions a studio might fulfil?

It undoubtedly forms or contributes to an artist's identity—the studio substantiates a claim to be an artist.

It's a pretext or alibi—it's a space that signals and licenses a certain kind of activity or thinking.

It's also a mnemonic device—literally answering the question "Now where was I?" asked of yourself when returning from an interruption to a process or project. The space and the arrangement of things in it, undisturbed, act as a physical model of memory. The objects around the desk, or bench or table, explain, as you reach for them, what you were doing last time and enable you to return to where you left off.

If we consider the first of these points in more detail we can clearly see the role of the studio in the construction of an artist's identify and self-image, to the extent that the studio emerges almost as a form of self-portraiture, where the practical processes of making art are most definitely not the only thing at stake.

In reality the artist's studio has hardly ever been an anonymous place acting as nothing more than a practical necessity to the making of art. In the catalogue for the 2009 Compton Verney exhibition The Artist's Studio curator Giles Waterfield proposes that "Studio or associated academy images have acted as a form of manifesto, from the [sixteenth] century prints of Baccio Bandinelli (1493–1560) onwards."[6] So much so that, he goes on, "for Alice Bellony-Rewald and Micheal Peppiatt, the authors of Imagination's Chamber, there is no need for scepticism over the clarity and reliability of the image of the artist's space".[7] For them "The studio is the artist", no less.[8] In a similar vein Brian O'Doherty describes, in his brilliant book Studio and Cube, 2008, the work of New York artist Lowell Nesbitt who in 1967–1968 photographed the studios of his colleagues. Nesbitt described the spaces as "portraits of the artists without their faces and bodies".[9]

In keeping with that role of surrogate for the artist, by the seventeenth century we can see the studio appearing regularly as a subject matter in itself, and one "through which artists could make their most ambitious statements about the nature of their vocation".[10] The examples are numerous, and many, from the British tradition at least, were brought together in the Compton Verney exhibition.[11]

For O'Doherty there are "four celebrated stations in European art where the studio becomes a manifest subject, each with an increasing consciousness of the studio space, each with a different social agenda".[12] The fourth and most self-conscious of these is Gustave Courbet's The Painter's Studio, 1855.[13] It acts as (and is made to look like) a busy theatre set, filled with characters as if on a stage—the drama at its centre being Courbet's métier articulated in the form of his studio as he pictures it. Here the studio is seen as a semi-public, social space. O'Doherty suggests it

may be, in the long history of the studio picture, "the first major formulation of the radical nature of this privileged space".[14] Courbet weaves into the painting his social and aesthetic agenda and produces an image of the studio resolutely at odds with the establishment studio of the period—a space Hugh Honour describes, via O'Doherty, as "smoothly continuous with the social order outside".[15]

If the more typical studio of the time, as it appears for example in Charles Giraud's paintings of his brother Eugène's studio,[16] is a place in which the values of the bourgeois are confirmed (and where also, O'Doherty suggests, after Baudelaire, they consign their alienated imaginations)[17] then Courbet's version refutes those values and frustrates any easy relationship. As O'Doherty points out, at the left of Courbet's painting is a canvas turned away from us, we see only its back, and through that concealment our curiosity becomes even greater. The reverse of the canvas becomes the motif for an urgent inquisitiveness, a demand to be shown, or to have revealed to us the 'alchemy' of the studio, but in the Courbet it remains a desire unsatisfied.

Coinciding with the development during the mid-nineteenth century of the museum, the Kunsthalle and the commercial gallery the role of the studio as a place of presentation was replaced with the image of the solitary artist in a private studio space. And despite the emergence of other models, and in some cases its reversion, by many contemporary artists, to another kind of social and presentation space, this image of the solitary artist's space still holds many ideas of the studio under its spell.

Howard Singerman's essay, "A Possible Contradiction", published in The Studio Reader: On the Space of Artists, 2010, considers the studio with reference to, amongst other things, both Leonardo's comments on the subject first circulated in 1519 and the American College of Art Association's 2008 guidelines for MFA programmes in "studio art" concerning the studio facilities appropriate to, and to be expected from, such courses. Singerman finds parallels—both are wary of the merits and dangers of isolation. "If you are alone you belong entirely to yourself" Leonardo writes and yet, as Singerman explains, "he also warns that the artist who withdraws completely courts madness". To work "in company" is suggested as preferable, for many reasons, including the effectiveness of shame and envy as teaching tools.[18]

Whether the studio is private or performed, the artist alone with themselves or caught in the tensions of pride and embarrassment, what each of these characterisations revolve around is the notion of a charged space, and one capable of (self) revelation. One of the things that it seems to offer or create is a hunger for insight. We seem driven by the idea that the studio can tell us something that is otherwise as inaccessible as Courbet's painting-in-a-painting—its back turned toward us. O'Doherty begins his book with a description of the Lucas Samaras work in which he transported his bedroom/studio to the Green Gallery in New York in 1964, reconstructing it and exhibiting it as art.[19] We can now find numerous contemporary variants on that same process—the recreations of Bacon's or Brâncuşi's studios being the most well known examples—though crucially they lack the artist's own agency or Samaras' critique of the mythology of the artist, and of the gallery.[20]

But even these cursory references begin to indicate how the studio can be seen to have played, or been consciously inserted into our understanding, or reading of the artist, and therefore the work. In each case we can reasonably ask if it's the studio reflecting the artist or whether the reverse is the case—that the studio (its stage management, or a representation of it) is creating an image, which is then projected onto the artist and their work. All this despite

the truth of Francis Stark's brilliant summation: "Sometimes I think my studio says as little about my work as a basket of dirty clothes conveys of what I look like."[21]

Despite such dismissals, the studio's significance is nonetheless reinforced by many of the critical positions built around or in opposition to it. Still influential today is Daniel Buren's 1971 essay "The Function of the Studio" which casts the studio as artificial and dislocated from the space in which art should be seen and therefore should be made—in situ, in the space of exhibition and the public.[22] Equally important in terms of contemporary approaches to the studio, and related in some respects through the similarly in situ work of Michael Asher, is the course at CalArts (California Institute of the Arts) begun in 1970 and led by John Baldessari, Douglas Huebler and Asher, which was (and still is) called "Post Studio Art". The idea of the studio that is being left behind in this case is the studio as a model of a particular, and a particularly problematic, type of art—insular and over-absorbed in technique and materials. Of course the studio as an actual resource remains even here—all the students on the course have studio spaces—but what is being contested is an idea, definition or history of the studio. An idea that is then used to define a counter position, the (conventional) image of the studio being the means by which a different practice can be seen, realised, and eventually theorised. And in reality, as Mary Jane Jacob suggests in her conversation with Baldessari published in The Studio Reader, while "the course was Post-Studio… the experience, I might say, was almost all studio"—referring no doubt to Asher's famous 12-hour studio crits.[23] The studio then as an idea, a history and a set of conventions, can be seen as a figurative space around and within which questions about practice, motive and purpose can be encountered and negotiated.

I've described the studio briefly here as a part of the mythology—in terms of a constructed narrative or identity—of the artist, as a form of self-portraiture and as a place 'against' which it prompts, or can be used to propose, concepts of art and art making. We can also see the actual space of the studio itself as a prompt for the artist to a certain kind of thinking—as an alibi or a pretext, and as a mnemonic. There is an anecdote about the Surrealist painter René Magritte that I've frequently heard recounted but is perhaps apocryphal as I've never managed to find any documented source of the story. However, even if a fiction it does brilliantly illustrate a crucial yet immaterial function of the studio, and its popularity indicates how well it resonates with an idea of what the studio offers. It's said that Magritte, who used the dining room of his home as a studio, would each morning put on his hat and coat and leave the house. He would walk around the block and come back in the front door again, go to the room that was his studio, take off his hat and coat and begin work. Here, the studio is clearly a construct for a separate, specific and distinct way of thinking—and the route by which a strand of thinking and activity can be returned to, where the artist can put themselves back into a process despite the interruption of their absence from that space and that activity. But how that return occurs, and what it is a return to, is itself not necessarily as direct as picking up tools, materials, pencils or brushes.

Michael Smith's essay "Recipe: Perfect Studio Day" captures what for him are the essential elements of a day in the studio, beginning with the 'to-do list' of "Wash dishes. Fresh Coffee. Window with a view. Quiet. Plenty of ideas. Room to pace." He goes on to explain his new-found passion: puttering. This process of "running in place" seems to act as an agenda by stealth, the artist reassuring himself "that everything eventually finds its place, including me".[24]

These seemingly 'incidental' undirected activities might seem peripheral to the 'real' business of the studio, but it may be that in fact they're the very things that are peculiar and exclusive to

this type of space—when the supposedly more important material or technical processes could really take place in any suitably kitted out workshop. The studio might be the only place in which an artist can:

think about making work;

talk about making work;

look at things;

show other people things;

have meetings with people;

do nothing in particular;

mess around with stuff;

have things go wrong;

and not know what they're doing—in a good way. (Or in a bad way too, since the studio can provide the space for a cycle of motivation, delight, doubt, failure, misery, persistence, satisfaction, doubt, etc).

And most artists (and many of the students involved in the seminars conducted as part of the project) would agree that these are all things they not only do in the studio, but crucially 'can' only do 'because' they have a studio. These immaterial, indirect activities are some of the places from which ideas occur, ideas that then might become works—and in this process the studio generates the plan, rather than being simply the place where the plan is executed.

Of this kind of ludic, aleatory, exploratory activity 'licensed' by this space called 'a studio' perhaps Bruce Nauman's much quoted statement from 1979 stands as its motif: "If I was an artist and in the studio, then whatever I was doing in the studio must be art."[25] And Nauman's practice has perhaps, through the related notion of the readymade and the recontextualizing capacity also seen in the gallery, most clearly interwoven the making of art with the space in which it's made. Perhaps like the trick that Magritte plays on himself, Nauman too makes his studio an alibi, a pretext, and a generative space—a space that doesn't make the art without first making the artist.

Practice and the studio are linked here just as they are in Daniel Buren's essay, but perhaps in reverse. Nauman's commitment to the studio is as a generative space from which work then enters a gallery or encounters a public. Buren on the other hand, despite seeing the link between practice and the studio as equally significant, proposes that work is meaningful only when made *in situ*—responsive or engaged with the site in which it is encountered. This casts the studio as just another site of production, but one that as the exclusive domain of the artist, lacks any contact with a public and becomes therefore redundant and irrelevant.

Nauman's works and Buren's essay and the practice they articulated (along with numerous other related works, statements and essays, notably the section titled "The Dislocation of Craft—the Fall of the Studio" in Robert Smithson's essay "A Sedimentation of the Mind: Earth Projects", published in *Artforum* in 1968) as well as the CalArts course and the concept of post-studio art associated with it are now very familiar to us.[26] They are key references in contemporary art, the history of post-minimalism, the ideas and practice of "institutional critique", and the ways in which artists think about and use the studio.

But nonetheless, as Jacob states, "We're really aware of how people use the studio and the idea that, in fact, it doesn't go away. Art making might change, but we still have a studio."[27] And perhaps furthermore, the received or paradigmatic model of the studio remains the predominant form. In London the single-user, exclusive space in a sub-divided building is by far the norm. As a result it becomes very clear and unavoidable that any idea of a studio today has to embrace a huge range of forms and functions, histories and critical positions—both radical and conservative.

If the primary question is: "What is a studio?", then, given the clear relationship between an artist's studio and their practice, it's also the question: "What is a practice?" and the answer to that will be as diverse and as contested as practice itself. Any seemingly straightforward questions about the actual physical form of a studio—design decisions regarding ceiling heights and floor plans—can immediately be seen to contain broader, much more complex and contingent questions about art making.

We might justifiably ask when these decisions would ever arise, because the predominant model of self-organised artists' studios is based on a history of reuse, not of purpose-built design.[28] Equally the making of new art school buildings is not something that occurs with great regularity. (Although there are some relatively recent instances, Central Saint Martins' new building at King's Cross, designed by Stanton Williams and occupied in 2011; or new centres like Renzo Piano's Modern Wing at The Art Institute of Chicago, opened in 2009; the Royal College of Art's Sackler Building designed by Haworth Tompkins, also opened in 2009 as the first part of the relocation of Fine Art to a new site in Battersea; Chelsea College of Art's move from Manresa Road to Millbank in 2005; and Alsop and Partners' Ben Pimlott building at Goldsmiths, also opened in 2005. Each of these, and any other similar situations, must have made necessary a reappraisal of the understanding and expectation of a studio environment.)

In terms of studio provision, Acme have led a fundamental shift in approach as the availability of, and competition for, vacant industrial spaces makes the 'reuse' model less and less viable.[29] In recent years, they have for the first time found themselves faced with the great opportunity to design a multi-occupancy studio building either partially or wholly from scratch. In doing so they have also been faced with the very difficult and complex question of designing for the unknown or the unpredictable—and in that context the issues I have described in theoretical terms become very real and require a practical, committed and unequivocal response. That this has occurred during the life of this research project has been an invaluable opportunity for both Acme and CSM to apply the work to concrete situations.

Despite being a very different context—that of the single-user, bespoke studio—the issues are expressed in two very different stories. Robert Storr explains that when Robert Motherwell, at the height of his career, moved to Greenwich, Connecticut he commissioned a new studio. But, he had it designed to be the exact size and proportions of his downtown Manhattan loft "so as not to lose his bearings". Setting aside the contradictions of Motherwell's capacity to commission a

purpose-built space in Greenwich and what Storr describes as a weakness for a *nostalgie de la boue,* the story does suggest something of the strange tensions between the comforts of making do with what is available and the lure of the bespoke.[30] More specifically, Michael Craig-Martin in his description of his own bespoke studio articulates the practical problems of studio building:

> I had the opportunity to design it exactly to suit the needs of the kind of work I have been doing over recent years. This was a pleasure but also a risk. I have found in the past that by the time one finally manages to create ideal working circumstances, the work itself can change and all one's carefully realised specifications can become instantly redundant.[31]

With a view to how these challenges can be negotiated realistically we must turn to the practical applications of some of the ideas I have outlined, to better appreciate the specifics—and the tensions between changing forms of studio practice. At the heart of the issue is the question of how a studio provider, or an art school, can usefully address the alternative, opposing or conflicting characterisations of what the studio should or could be, within the constraints that apply.

To put this simply, the opposite poles of these characterisations might be seen as, on the one hand, the received idea of the artist's studio: exclusive, private, highly personalised, a physical manifestation of the artist's 'world', and on the other, the post-studio studio: collaborative, collective, mobile, temporary, shared, open-plan, a project space.

To think of this in pragmatic terms, common to both are some fundamental practical issues. For Acme there are the essential and overriding factors: the studio must be affordable, safe, secure, weatherproof, fully accessible, with a goods lift and wide corridors and doors. But there could be other considerations, for example it might have communal space, or exhibition/project space, and general flexibility—with moveable walls/partitions, open-plan, shared and cooperatively used space. However, if it meets these needs it must do so only if it can maintain the overarching principle of affordability, and in reality the inclusion of communal, project or exhibition space reduces the lettable total and increases the cost to the individual artist.

Two of Acme's recent studio developments have provided the most clearly defined opportunities to address these complex requirements in real building projects, and have drawn directly on the research done as part of the collaboration with CSM. The first is High House Artists' Studios, a multi-occupancy artists' studio building designed from scratch in Purfleet, on the eastern outskirts of London. The second of these, the Associate Studio Programme at the Glassyard Building, a new-build student Hall of Residence combining studios and work/live units in Stockwell, South London, is the one that has the most direct relationship to the work done with students at CSM. Both are written about in detail in other chapters of this book, but what I will say here is that what they both illustrate very well is the need to understand the issues, and any potential to address them, in terms not 'just' of the static 'bricks and mortar' of the building but also the dynamic 'activity' of the building's management, how the building is occupied and how it is used. In fact in both cases the design of the spaces is not necessarily the most significant issue. The Glassyard space is an open-plan studio with eight separate artists sharing the space with individual tenancy agreements, and that is certainly unusual. High House Artists' Studios has been designed to be extremely cost-effective in terms of the building and the running of it. In appearance neither is radically different to many other multi-user studio buildings. What is genuinely radical is the context out of which

they have been conceived and the means by which they have been achieved. The partnership between Acme and CSM has been central to the whole process, and in the case of the Associate Studio Programme it is the collaborative relationship that has been especially valuable as a way to recognise and create new kinds of collective or cooperative use.

To conclude this chapter, what the partnership has done in general terms is prompt a long and hard look at the issues at play and the explicit, and the implicit (or even inadvertent), priorities used to resolve the numerous contradictory or irreconcilable demands and needs that intersect in the multi-user studio building. It's here that CSM finds common or overlapping concerns in how it too provides space for students.[32] The purpose of this project was not to work on the question of the studio in the art school but it did develop from a concern for that. The need for such work has grown since we began our partnership and it may be that the findings can play a part in that process, bringing it back to the art school directly, in addition to achieving, far sooner than we envisaged, a real working model for the support of recent graduates in London.

*Much of the thinking for this essay has developed during the course of the project and benefits from conversations with colleagues, as well as undergraduate, postgraduate and research students at CSM. In particular I'd like to acknowledge the invaluable part played by Professor Anne Tallentire, Dr Giovanna Morra and Stephen Johnstone.*

## Notes

1   The title of this essay draws on a paper by Anne Tallentire and Graham Ellard presented as part of Friends of Art, a symposium, originally proposed with David Burrows, discussing collaboration and the research project Double agents, with Adam Chodzko, Emily Wardill, Uriel Orlow and Ruth McLennan, at ELIA 8 Biennial Conference in Luzern, Challenging the Frame, 3–6 November 2004.

2   The exhibition was curated by Jens Hoffman and Christina Kennedy for Dublin City Gallery The Hugh Lane. The history of the relocation of Bacon's studio is recounted here: http://www.hughlane.ie/history-of-studio-relocation (last accessed 25 February 2015). For full publication details of selected titles please see the bibliography.

3   What's the point of Art School?, a series of public events in April and May 2013 initiated by Jeremy Till, Head of College, CSM, and proposed and led by college staff, by open invitation. The series included a one-day conference and numerous symposia involving a range of contributors, amongst them: writer Owen Hatherley; Professor Ute Meta Bauer, then Dean of Fine Art at the Royal College of Art; curator Sally Tallant; artists David Burrows, Bob and Roberta Smith; journalist Suzanne Moore; architect Paul Williams; former Member of Parliament Kim Howells.

4   The beautifully produced 600 page book *Sanctuary: Britain's Artists and their Studios* is a perfect recent example from 2011, and in many ways resembles the earlier book *Artists at Work: Inside the Studios of Today's Most Celebrated Artists* from 1999. Both echo qualities of the 1965 book *Private View:*

*The Lively World of British Art,* though perhaps importantly this embraces a context beyond the studio drawing in galleries, curators, art historians and arts schools—interestingly describing this world on the dust jacket as a "complex organism that is British Art today". For full publication details of these titles please see the bibliography.

5   I'm not proposing an absolute distinction between thinking and making here, but I am characterising making as a process of completion. There is something in between—perhaps 'doing' (trial and error, material experimentation, play, rumination, etc) which best sums up the difference I am trying to suggest between a studio and a workshop.

6   Waterfield, Giles, ed, *The Artist's Studio* (exhibition catalogue), London: Hogarth Arts in association with Compton Verney, 2009, p 1.

7   Bellony-Rewald, Alice and Michael Peppiatt, *Imagination's Chamber: Artists and their Studios*, Boston: Little, Brown and Co, 1982, pp vn–vi. Quoted in Waterfield, Giles, ed, *The Artist's Studio*, p 1.

8   Bellony-Rewald and Peppiatt, *Imagination's Chamber: Artists and their Studios*, pp vn–vi. Quoted in Waterfield, Giles, ed, *The Artist's Studio*, p 1.

9   O'Doherty, Brian, *Studio and Cube: On the relationship between where art is made and where art is displayed*, New York: Princeton Architectural Press, 2008, p 12.

10  Cole, Michael and Mary Pardo, ed, *Inventions of the Studio, Renaissance to Romanticism*, Chapel Hill: University of North Carolina Press, 2005, p 19, quoted in Waterfield, Giles, ed, *The Artist's Studio*, p 1.

11   The Artist's Studio was curated by Giles Waterfield at Compton Verney, Warwickshire, 26 September–13 December 2009. Notably, among many other fascinating examples, in *Interior of a Studio* (as named by Waterford, elsewhere referred to as *Studio Interior*) by Octave Tassaert (1845, oil on canvas, 46 x 38cm) the studio becomes a part of a story that artists tell the world, and tell themselves. It is not a self-portrait but this image of a young impoverished artist in a garret, huddled in front a meagre fire, his easel abandoned, is no doubt talking in part of the 45 year-old Tassaert's own frustrated artistic ambitions. Another notable painting, included in the show, is *The Sleeping Model* by William Powell Frith (1853, oil on canvas, 63 x 73cm) with its curious doubling of the model and a dummy figure, slumped immediately behind the sleeping sitter. That the small portion of the painting that can be seen depicts the sitter wide-awake subtly suggests the artifice of the situation.

12   O'Doherty, *Studio and Cube*, p 7.

13   Gustave Courbet (1819–1877) *The Painter's Studio: A Real Allegory* (1855, oil on canvas, 361 x 598cm). Full title: *The Painter's Studio: A Real Allegory Summing Up Seven Years of My Artistic and Moral Life*. The painting is an allegorical representation of Courbet's career and features a cast of friends and allies, including writers George Sand and Charles Baudelaire.

14   O'Doherty, *Studio and Cube*, p 9.

15   O'Doherty, *Studio and Cube*, p 10.

16   O'Doherty doesn't specify but perhaps the most widely known example is *Eugene Giraud (1806–1881) in his Studio with his Brother, Charles and his son, Victor,* (1853, oil on canvas) by Charles Giraud.

17   O'Doherty, *Studio and Cube*.

18   Leonardo da Vinci, from various manuscripts published in 1651 as *The Treatise on Painting*, quoted in Howard Singerman, "A Possible Contradiction" in Jacob, Mary Jane and Michelle Grabner ed, *The Studio Reader: On the Space of Artists*, Chicago: University of Chicago Press, p 39.

19   O'Doherty, *Studio and Cube*, p 4.

20   In fact perhaps there is an agency at work, but it isn't declared. In his essay "Brancusi's 'white studio'" Jon Wood describes the sculptor's space, up to and including his white Spitz dog, Polaire, as "an elaborate construct" as "part of a self-consciously crafted 'artistic identity'". See Jacob, Mary Jane and Michelle Grabner ed, *The Studio Reader: On the Space of Artists*, p 269. Equally, in a review of the exhibition The Artist's Studio in *The Guardian* online http://www.theguardian.com/artanddesign/2009/sep/28/the-artists-studio-exhibition (last accessed 25 February 2015) Maev Kennedy describes early images of Francis Bacon's showing a far more orderly space than the famously chaotic and cluttered studio seen and fixed in Perry Ogden's photographs of 2010.

21   Francis Stark in her untitled essay in Jacob, Mary Jane and Michelle Grabner ed, *The Studio Reader: On the Space of Artists*, p 48.

22   Buren, Daniel, "The Function of the Studio" trans Thomas Repensek, *October*, vol 10, fall 1979, pp 51–58.

23   Jacob, Mary Jane, "John Baldessari: In Conversation", in Jacob, Mary Jane and Michelle Grabner ed, *The Studio Reader: On the Space of Artists*, p 30.

24   Smith, Michael, "Recipe For A Perfect Studio Day", *The Studio Reader: On the Space of Artists*, p 28.

25   Bruce Nauman in conversation with Ian Wallace and Russell Keziere, *Vanguard*, vol 8, February 1979, pp 15–18.

26   Smithson, Robert, "A Sedimentation of the Mind: Earth Projects", *Artforum*, September 1968, p.44. Included in Jack Flam, ed, *Robert Smithson: The Collected Writings*, Berkeley: University of California Press, 1996, pp 100–113.

27   The quote from Jacob's conversation with Baldessari continues, "So all of that said, we come to a question that is really very personal: What does the studio mean to you? Why do you have a studio? You have four and a half of them, or maybe more—you're not sure." Baldessari describes his numerous studios and their respective functions, while also explaining that when he took the job at CalArts he was offered a studio. He goes on "So I said, 'No, I'll pass on that'. And by that time, I was a fully-fledged conceptual artist. You know, they don't need studios. God forbid that it leaked out that I had a studio. [*Laughs*]." Jacob, Mary Jane, "John Baldessari: In Conversation", in Jacob, Mary Jane and Michelle Grabner eds, *The Studio Reader: On the Space of Artists*, p 31.

28   This model takes advantage of the existence of de-commissioned or empty industrial space, of low market value (making cheap leases attractive to the buildings owners), to create secure, self-contained, well-lit, safe and legal studios. Using this approach Acme now has long leases on or owns over nine large ex-industrial buildings.

29   If we look at the historical model under current circumstances we see that today the cold and dirty warehouse studios of New York and London have been transformed into expensive apartments, and artists and studio providers find themselves pitted against far wealthier competitors for what has become an extremely valuable but still a finite resource. In 2011 the New York apartment that was previously one of Barnett Newman's studios could be seen on a real estate website, up for sale at over $2million, with a sales pitch that not only acknowledges its past use but very obviously uses it as a positive selling point. See http://ny.curbed.com/archives/2011/11/17/former_studio_of_color_field_painter_barnett_newman_for_sale.php (last accessed 25 February 2015). Equally there is something wholly predictable and deeply depressing about the fate of the original St Martins' building in central London. Since the college sold the building to Foyles and moved to King's Cross, the top floors have been converted into 'luxury penthouse apartments'. Named The Saint Martins Lofts they are promoted as much by the building's former use as by the specifics of the apartments themselves.

30   Storr, Robert in "A Room of One's Own, a Mind
     of One's Own" in *The Studio Reader*, p 50.

31   "Artists' studios: Michael Craig Martin" (from
     the "Artists' studios" series of short pieces),
     *The Guardian*, April 2008. See also http://www.
     theguardian.com/artanddesign/2008/apr/04/artists.
     studios.michael.craigmartin (last accessed 25
     February 2015).

32   While acknowledging that an art school relates to
     'professional' practice it is important that it remains
     distinct from it. Students are students and must be
     granted the opportunity to act in all the ways that
     that implies: speculative, obsessive, explorative,
     learning through mistakes and failures as much as
     success, and being sufficiently unencumbered to
     do so.

# INVESTIGATING THE STUDIO

ARANTXA ECHARTE

3

**In April 2010** I was appointed Associate for the Knowledge Transfer Partnership initiated by Acme Studios and Central Saint Martins.[1] A discussion about the form and purpose of artists' studios between Jonathan Harvey of Acme and Graham Ellard of CSM had by then materialised into a two-year funded research and development project. For me, this presented an exciting opportunity to work with two collaborating organisations that on the one hand held the accumulated knowledge of 40 years of studio provision, and on the other is a leading art school preparing artists and potential studio users of the future.

The main aim of the project was to develop new briefs for the design and management of Acme's studios. The underlying imperative was to sustain and, where possible, increase the affordability and quality of studios. The first steps of my engaging in the partnership involved familiarising myself with Acme's activities—from the principles on which the organisation was established to the day-to-day operations of letting, management and development. To be embedded in the company from day one was of enormous value. With 14 buildings, providing studios for 650 artists, there was a great deal to become familiar with.

Accompanied by Acme colleagues I visited each of the studio buildings located in different areas across London.[2] Drawing on their knowledge and experience I began to understand the nature and context of each site—in particular in terms of size, design and studio allocation criteria. In parallel, I studied the Acme property and tenant databases to position these site visits within the larger statistical picture of Acme's provision as a whole, looking for tendencies and anomalies. This approach involved the collation of a comprehensive record of the types of buildings that Acme had developed—conversion, new-build, work/live—and was followed by an empirical enquiry into the kinds of practices being undertaken, and the various ways in which tenants use their spaces.

Most of this preliminary research was conducted through accessing Acme's records and visiting each artist's (or their gallery's) website. The data analysis was shaped and expanded through the addition of specific fields of enquiry: how long the artist had been in their studio; the average age of tenants in specific buildings, and across all buildings; number of years since graduation; the size of the studios; and the distance of the studio building from the artist's home address. Each category was created by the KTP team through discussion aimed at identifying the most pertinent characteristics or conditions at play.[3] Ultimately we intended to use this analysis to understand the priorities and profiles of existing tenants. Through this we could devise the criteria by which we would select a number of artists for one-to-one interviews. For this selection to be truly representative of users of Acme's studios it would be necessary to tease out all of the myriad parts that make up their constituency. Not all artists are the same, in fact it's probably more accurate to say that 'no two' artists are the same; each artist understands and uses the studio in different ways. However, we felt that we had to define and capture the information most relevant to studio use if the research was to serve as a reliable record upon which future decisions could be made, and which might in the process reveal otherwise unnoticed patterns or trends.

### Uses of space

In the process of gathering data on the kind of work being made across the various sites, seemingly straightforward facts emerged. For example, in December 2010 60 per cent of Acme tenants were working with painting, drawing and printmaking, 20 per cent were makers and 20 per cent worked with other media.[4] By cross-referencing figures collated from site to site it emerged that in long-established buildings the proportion of artists working with painting,

drawing and printmaking was similar, but the percentage of makers was higher than that of other media users. Interestingly the percentage of other media users increased considerably in the more recently established buildings, indicating a shift over time from sculptural production to other ways of working.

It also became apparent that the percentage of space occupied by artists working with painting, drawing and printmaking was directly proportional. By this I mean that in a building where 60 per cent of artists work with painting, drawing and printmaking, they might typically occupy 60 per cent of the total floor area. This was not the case for artists working with other media. In a building where 15 per cent of the total number of artists work with other media, they might only occupy 10 per cent of the total floor area. On looking at Acme as a whole I observed that in more recently established buildings, while the number of other media users increased, the area these artists occupied decreased.

However, in the discussions I had with Acme tenants, the significance of the category of discipline in relation to how artists work, and thus how space might be used, was comprehensively challenged. On visiting Eryka Isaak at Childers street in July 2011, she stated that she would not like her work to be defined by discipline. "I would definitely say that I am involved in creative practice. I would rather not try to decide which one it is", she said. In an interview in September 2011 Dryden Goodwin elaborated on the various uses of space when moving from one discipline to another, explaining that he requires a studio to provide a diagrammatic space where he might be able to produce, compare and contrast works with a clear sense of timeline and development, but at times he seeks out a more virtual and abstract space, such as that found when working in an editing suite.[5] At this stage it already seemed apparent that flexibility—in terms of adaptability to multipurpose use—might be a key concern in the development of new studio design and performance briefs.

The data also revealed that artists occupying Acme's earliest building at Robinson Road have an average studio size of 467ft$^2$ (43m$^2$). This is an ex-industrial building (used originally as a brush factory) and, as happens in the refurbishment of this type of building, these studios are the result of a natural subdivision often determined by the existing windows and walls. In more recently developed Acme buildings, however, where the subdivision of space is determined by Acme's design and performance specification, the average studio size decreases considerably.[6] This shift in design is likely to have been driven by Acme's prioritisation of affordability, but it raises new questions as to whether such a trajectory occurred as a specific and potentially short-term response to economic recession, or will be sustained longer term in the face of ongoing increases in the price of property in London, and whether it is also defined by a broad and lasting shift in contemporary art practice (influenced perhaps by changes in art education).

The answers might be any of the above, but what the research made clear is that renting workspace is a substantial financial commitment, and at present many artists can only afford the rent by taking a job at the expense of time in the studio. In her interview in June 2011 Rebecca Stevenson summed this up when she said that, "a lot of the people here cannot use their space because they work full time to pay the rent to have the space that they cannot come to. It is a real conundrum." Seemingly we might continue to see demand shifting towards smaller studios due to affordability factors and we might continue to see artists adjusting their practices to fit those spaces. However, it is important to look at studio models of all types and sizes and think about new possibilities for use.

Three Acme buildings illustrate very well the different types of scenarios we are encountering at the moment and we need to be aware that other new ones might come up in the future. Acme's smallest studios at High House Artists' Studios in Thurrock, 127ft$^2$ (12m$^2$), were the first to be occupied, and being the most affordable, have, since the opening of the building in July 2013, attracted the highest demand. However, in September 2014 Acme opened a new building, Warton House, in SE15, with studios ranging between 330–930ft$^2$ (30–86m$^2$). These studios are also extremely popular and were occupied from day one. A different model of use of space at Acme is Studio 109 at the Glassyard, London, SW9. This studio, which measures 1,300ft$^2$ (121m$^2$) is occupied by eight recently graduated artists. If we do the maths each artist is allocated just 150ft$^2$ (14m$^2$) However, this studio, following the artists' request, does not have any partition walls and each individual can therefore occupy the actual space they need depending on the type of work they are doing at any moment, by negotiation with their peers. In this case the dedicated studio space may seem to be following the trajectory of affordable studio provision getting smaller, but rather than adjusting their practices to fit those smaller spaces the newly graduated artists are adjusting their uses of space.

### Trends and expectations

In 2010 the average Acme tenant was 45 years old (the youngest being 23 and the oldest 85). The KTP team queried why this might be the case: did a low turnover of tenancies mean that older occupants would inevitably outnumber the younger? Were younger people following specific trends in contemporary art that did not involve a traditional studio practice? Was it possible that UK graduates could no longer afford to rent a studio due to the considerable debt they might face at the end of their studies? Were there any other reasons why organised studios would not be suitable for younger artists? Were they actually aware of Acme and its studio provision?

During our initial data analysis we briefly cross-referenced the age of occupants in each building and their disciplines of practice. In the case of one site, where the demographic was generally older, the percentage of artists working with other media was 25 per cent. Conversely, at the site with the youngest demographic it was only 16 per cent.[7] This undermined any assumption that younger artists were increasingly favouring alternative media, which in turn halted speculation that in future the demand for smaller spaces might increase. The initial study of the existing tenants' ways of working did not enable us to make entirely conclusive statements or specifications for studios. More research was required.

The question of future requirements motivated the programming of a series of seminars with BA and MA Fine Art students, and joint workshops with students from the BA Architecture: Spaces and Objects course, at Central Saint Martins. Run by Graham Ellard and myself, the broad aim of the seminars was to draw out and examine student expectations and priorities regarding their potential studio needs following graduation.[8] The sessions began with a general introduction to the KTP project, a description of Acme's studio provision and a brief contextualisation of the concept and history of the artist's studio. This was followed by a structured discussion focused on questions such as: What are you planning on doing—in terms of studio practice—once you finish your degree? What are your main priorities when looking for a studio? How would you define your perfect studio?

While the discussion did reveal certain pragmatic expectations, on the whole, to our surprise, the students did not appear to have much of an understanding of the studio provision sector,

Childers Street SE8
Images of Studio 80, October 2010
Photograph: Moz Bulbeck, 2010–2012

such as knowledge of rent levels, or how to go about finding a studio. Initially, some spoke of wanting a big space all to themselves, but after further discussion new priorities emerged indicating that the majority of students wanted a communal space and the support of their peers. To some extent what they were describing was an extension of the art college shared studio model and this in turn raised a more complicated question: What kind of provision could include some of the qualities that the students were looking for, but at the same time help them with the transition from college into the professional art world (ie finding a space, paying rent, being part of an active community, using the studio effectively, etc)? And how could they avoid the kind of pitfalls encountered by artists such as Rebecca Stevenson? She reflected in her 2011 interview, "I think it is quite easy to get a space, get really excited, find a cheap place with some friends but then find that it is too cold to work in or the landlord is going to mess you around or you are not going to find the time to be there."

In early 2012, a decision to address the low numbers of younger artists occupying Acme's studios, coupled with the possibilities tested through the CSM seminar programme and a commitment to supporting more artists at the beginning of their careers, prompted the idea of a studio scheme designed specifically for recent graduates, with rents affordable to them. In mid-2013 an opportunity arose for Acme and CSM to implement such a programme at a new property development in Stockwell.[9] This resulted in the design and launch of a two-year Associate Studio Programme, a highly affordable shared studio space for CSM graduates, with an integral programme of studio visits by artists, writers and curators. Following the success of this programme Acme Studios and CSM are now discussing a second Associate Studio Programme at the Highline Building at Elephant and Castle, London SE17.[10]

Throughout the research it became increasingly apparent that Acme's studio provision needed to be responsive to the needs of young graduates and aware of new modes of studio occupation influenced by shifts in art education and social and economic factors. Changes in the flexible and non-permanent uses of space at art colleges mean that younger artists might find it appropriate and fitting to work in smaller and/or shared spaces, if this means they can afford to have a space where they can develop their work.

### Management and benefit

Acme's management model is generally based on an "arm's-length" landlord-tenant relationship, essentially aimed at establishing trust. Acme offers secure (in terms of tenancy) and safe (in terms of privacy) environments for artists. By occupying a long-term and affordable studio, Acme tenants have the opportunity to work and plan around the rest of their life commitments. Being an artist myself, I know how relevant and valuable these aspects are.

While the design and performance specifications for Acme studios focus on the provision of safe and affordable workspace, there are advantages in working within mixed-use buildings, which accommodate residential as well as studio space. In her interview in July 2011, referring to her studio, Yukako Shibata explained, "I work until very late in the evening and I feel safer knowing that someone is living upstairs. Before, when I worked in big buildings, I used to think that I could be the only person in the building. I don't get any of these unnecessary scary feelings. When I finish work I don't need to run to the station… I think this is quite important."

Applying a research methodology here, however, entails asking how we might measure the benefits of Acme's overall approach to management. One option would be to look at Acme's

Childers Street SE8
Images of Studio 80, February 2011
Photograph: Moz Bulbeck, 2010–2012

occupation rates, revisit the initial data regarding how long each artist has been in their studio and from this determine levels of satisfaction and sustainability.[11] But this alone will not fully convey the impact that an Acme studio has on an artist's practice and way of working.

During a team discussion on assessing the progression or 'success' of an artist in relation to their tenancy in an Acme studio, we decided to attempt an exercise where we adopted the ranking system used on one of the web-based tools aimed at auction houses, gallerists and collectors. Undertaking an analysis based on such data would inevitably be partial, with a bias towards certain measurements of value—the market, exhibiting with specific types of institutions, affiliation with collections. Nonetheless, within these terms, we felt the exercise could be revealing and of some, albeit conditional, relevance.

The site artfacts.net rates artists with a point system that indicates the amount of attention each particular artist has received from art institutions (the lower the number, the higher the rating). These points help to determine the artist's future auction and gallery sales and enables users to track upcoming trends in the market.[12] In December 2010 we conducted an analysis that demonstrated that 175 out of 456 Acme tenants were at that time being rated by artfacts.net, 1,792 being the highest rating and 40,863 the lowest. This translated into a percentage of 38 per cent of practitioners rated, with an average rate of 21,327. Artists rated on artfacts.net in July 2011 included: Martin Creed (244), Rachel Whiteread (341), Grayson Perry (1,057), Fiona Rae (2,187) and Dryden Goodwin (8,844), each of whom either currently occupies an Acme studio or has done so at some stage in their careers. These numbers are not deemed of relevance to Acme's studio allocation decisions, as Acme does not make a qualitative assessment of an artist's practice when they apply for a studio space.[13] However, this data may well support the idea that for certain artists who have received such attention their affordable, safe and secure Acme studio could have been key.

**Oral histories**

The testimonies referred to in this text are excerpts of the interviews I carried out with artists following data gathering, studio visits, student debates and a study of relevant literature. Gathering empirical evidence has been central to the overall project and the selection of interviewees was a critical process—it would not only offer insight to the priorities and profiles of existing tenants, but also influence the direction of further research into how Acme might improve the quality of its studio provision. Our intention was therefore that the interviewees would be loosely representative of tenants of all of Acme's London buildings—both converted and new-build. After a long debate, selection was based on contrasting three aspects: objective factors including age, the number of years an artist had spent out of college, the size and location of the studio and its distance from home; practice-related factors including the nature of the work and the processes, materials and technologies employed; and a range of personal factors and lifestyles such as number of days per week in the studio where studio time might be set against commitments to family and/or work elsewhere.[14]

In preparation for the interviews, I asked each selected artist to fill in a questionnaire that provided details of their career to date, specific practices and regularity of studio use. Then followed a series of (on average) 90 minute 'oral history' interviews that focused not only on the role and function of the studio for each artist, but captured in parallel more general contextual information associated with each artist's life and the development of their practice.[15] I interviewed each artist in his or her studio—what better place to hold the interview than in the space they inhabit with their work?[16]

Childers Street SE8
Images of Studio 80, June 2011
Photograph: Moz Bulbeck, 2010–2012

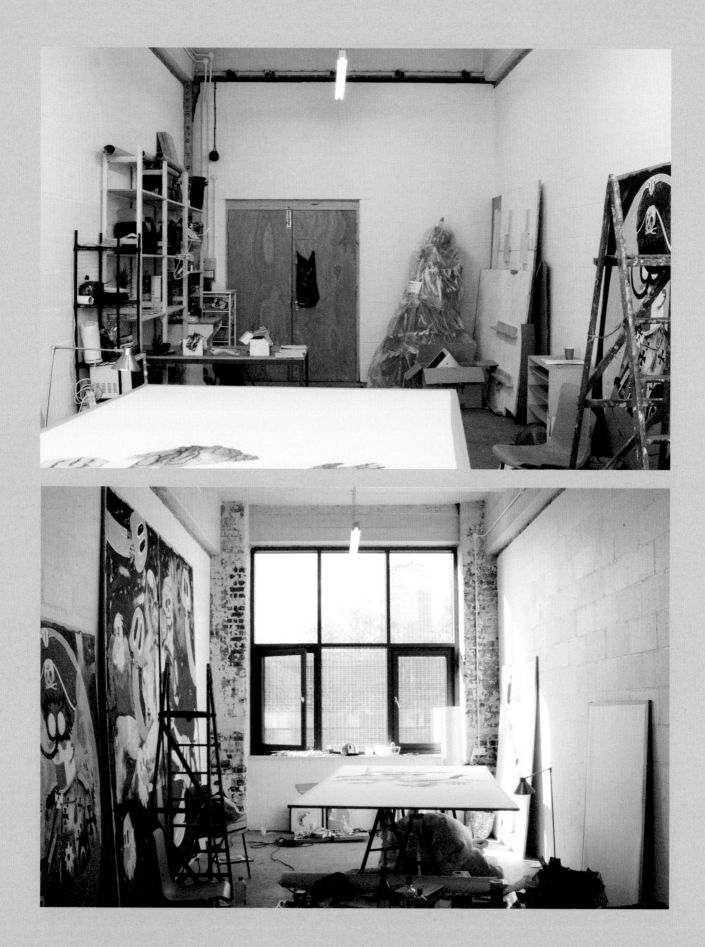

In collecting these oral histories it was important to retain the foremost aim of the interviews—that they captured direct feedback that might lead to improving the design and performance of Acme's studio buildings. They surely did! The interviews brought to light current trends in contemporary art education and subsequent practice, illustrated the function of the studios and the effect space has on modes of working, facilitated feedback on the existing design of the studios and asserted the relevance of Acme's mission.[17]

Many of the interviewed artists commented on the fundamental necessity of a studio and met the question "Why do artists have studios?" with the answer that not having a studio was unimaginable. Yukako Shibata claims that for an artist the space is essential "not just physically, but psychologically". For Franco La Russa the studio elicits communication: "When I have an idea and have enough to say I come to the studio." Fiona Rae describes a temporary suspension of reality: "I make the world in my studio", she said. While Paul St George asserts that "When you are in the studio everything else can wait."

On the practical uses of studio space Jonathan Baldock observed that "When you see all your work around you, the work feeds the next piece of work that you make." Clare Qualmann appreciated the essentials such as "Good heating… square, flat walls. These are straightforward things in a new building but it is amazing how important they are." David Lock commented on how "It is difficult to find quiet places [to work] in London". Robin Mason declared "I love this light and the fact that you can lock the door behind you. It is safe. You can leave your work here and it is safe".

Another management-related aspect to note here is the implementation of 24-hour access to all Acme buildings. Artists working towards deadlines may need to access their spaces and work at any time of the day or night. During her interview Eryka Isaak highlighted how important the 24-hour access is as it reduces pressure on the time in which she would otherwise need to access the studio.

**The wider context**

The artist's studio is a subject that has been studied in many different ways. Some of the literature produced since the 1960s has approached the idea of the studio as an historical trajectory (*Inventions of the Studio, Renaissance to Romanticism*, 2005), others architectonically (*Artists' Studios*, 2009). Some document the range of studios and the atmosphere of a specific time in a specific place (*Private View*, 1965), while still others raise questions about the relationship between studio practices and their wider political, economic and cultural context (*Machine in the Studio*, 1996). Some writers identify interviews, and their discussions with artists or art workers, as a tool to investigate what happens inside studios (*Artists at Work*, 1999) or to examine the present nature of the studio (*The Transdisciplinary Studio*, 2012).[18] An interesting typology presents artists portrayed within their studios. There are several of these but it is worth highlighting the book *Sanctuary: Britain's Artists and their Studios,* 2011, which presents 120 artists in a large, fully illustrated 600 page book. Interesting indeed, although it relies on well-known artists and tends towards the celebratory rather than the critical. There are two books that reflect another trend in contemporary culture, the production of the reader, *The Studio*, 2012[19] in the UK and *The Studio Reader: On the Space of Artists,* 2011, in the United States. It is interesting to see the crossover between these two readers as it reveals the existence of a common discourse that takes us back as far as Daniel Buren's essay "The Function of the Studio" written in 1971, and revised in 2007.[20]

One important aspect that the above literature does not portray is the studio within a studio complex that is managed by a studio provider—ie the studio provision sector, despite this being

Childers Street SE8
Images of Studio 80, October 2011
Photograph: Moz Bulbeck, 2010–2012

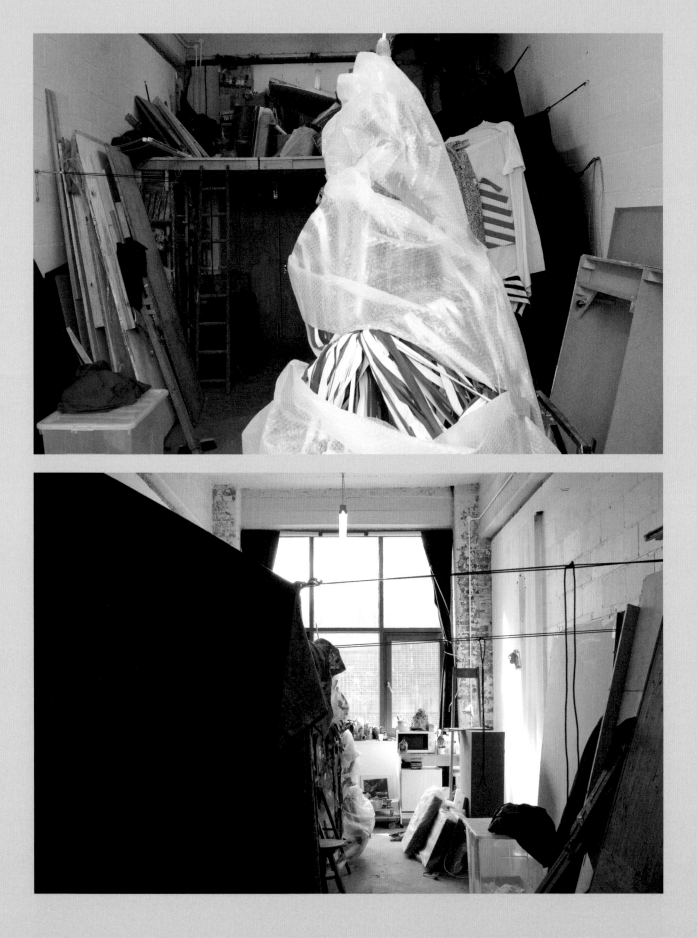

statistically the predominant model, and a key component in the ecosystem of the "art world" in London. In addition, most of the existing literature focuses on the studios of well-known artists and therefore fails to take into consideration the situation of the artists that are also central to the sector—ie those that are still seeking to establish their practice. Without proper critical analysis this sector may not develop to create the best conditions for emerging artists and their work.

With this in mind, and to further contextualise Acme's activity, I visited a number of other UK studio providers (and buildings) and interviewed the directors at ACAVA, APT, Creekside Artists, Gasworks and Mother Studios in London; Bar Lane Studios in York; East Street Arts in Leeds; Platform Arts in Middlesbrough; The Art House in Wakefield; and The Briggait (Wasps Studios) in Glasgow. I found that the aims of each organisation broaden rather than consolidate a generic approach to provision. Here, as in the case of the studio, there are a myriad of characteristics that define the services and spaces that a managing body provides.[21]

Perhaps it is most appropriate to look at the wider context of the studio in much the same way as Wouter Davidts describes it in *The Fall of the Studio: Artists at Work*, 2009, as "a complex one and one that needs to be addressed through a critical engagement with its multiple historical legacies and with the different modes and modalities in which it is used, displayed, represented or 'practiced' by artists".[22] An ambitious but necessary task.

### Photographic investigations

As a companion to the interviews, we commissioned the photographer Hugo Glendinning to document Acme tenants and their studios. This resulted in an extensive visual essay imbued with Glendinning's singular approach to the subject, which can be seen in chapter four of this book.[23]

From the outset of the project, we had considered how documentation might contribute to the research. In 2010, Acme refurbished 16 new studios at the Childers Street building in Deptford, SE8. It is not common to gain access to artists' studios when they are being newly occupied, but here we could potentially photograph quasi-identical studios, from fixed points, at four-month intervals over 18 months. We could examine the way in which artists organise and use their studios from day one. We secured permissions and asked the artists not to move or change anything when the studio was due to be photographed, as we wanted to observe the uncontrived development of each artist in his/her studio over the 18-month period. The systematic documentation of the studios created an illuminating photography-based investigation that brought to light different ways in which artists organise their space, use the studio and how that changes over time.[24] The accumulation of photographs revealed a surprising find. From looking at them one could extrapolate that these artists' spaces took approximately a year to shape and it took each tenant approximately two years to fully settle in. This visual observation potentially strengthens advocacy for long-term tenancies that provide stability and time for a practice to develop *in situ*.

### Applying the findings

In January 2013 the KTP team delivered revised design and performance specifications that covered a number of different studio types and development models. At the core of this we retained Acme's objectives of studio provision that is economic to build, meets changing user requirements and is fully occupied. The overall outcomes of the project exceeded initial aims and expectations; the research process contributed to a diverse set of valuable and transferable outputs: a stand-alone studio building (High House Artists' Studios), a new programme for

Childers Street  SE8
Images of Studio 80, April 2012
Photograph: Moz Bulbeck, 2010–2012

recently graduated artists (the Associate Studio Programme), and a tenant survey. Of those outcomes High House Artists' Studios and the Associate Studio Programme are discussed in more detail elsewhere in this book.

Acme started to work on developing a comprehensive tenant survey in 2008.[25] The initial draft became the basis for a longer questionnaire that supported the work carried out during the KTP. In early 2013, the team completed the design of the survey on the understanding that it could become a valuable means to regularly record information about Acme tenants. It would also give artists the opportunity to comment on how the building they inhabit performs, how Acme manage their services, and how an affordable studio contributes to the development of their practice. The Acme Tenant Survey was launched in October 2013 and will inform Acme's future work and response to artists' needs.[26]

The KTP project offered a unique opportunity to develop extensive research into the form, function and meaning of artists' studio provision. The team continues to work together and meets monthly to discuss further possibilities for collaboration.[27] Knowledge gained through this process is reflected and shared in numerous symposia and conferences, nationally and internationally.[28] The project produced important resources for the Acme archive that can be further expanded over time, such as the initiation of a collection of oral histories and a distinct approach to photographic documentation, both of which will become accessible to the public in early 2015.

*Thanks to Caroline Woodley for her editorial support and contribution to this essay.*

Notes

1   Knowledge Transfer Partnerships (KTP) are a UK-wide programme enabling businesses to improve their competitiveness, productivity and performance. This project was established with a Fine Art focus, which is unusual as KTP funding is normally awarded in areas such as design, engineering and science to develop concepts and/or products through the input of an academic specialist. During the project I was employed full-time by Central Saint Martins (the knowledge base) and seconded to Acme Studios (the company).

2   I visited Carlew House (est 1996, SE27), Childers Street (est 1990, SE8), Copperfield Road (est 1992, E3), Fire Station (est 1997, E14), Galleria (est 2006, SE15), Harrow Road (est 2010, NW10), Leven Road (est 2009, E14), Matchmakers Wharf (est 2012, E9), Oaks Park (est 1992, SM7), Orsman Road (est 1983, N1), Robinson Road (est 1981, E2) and Rowse Close (est 2001, E15). More recently established studios include the Glassyard (est 2013, SW9), High House Artists' Studios (est 2013, RM19) and Warton House (est 2014, E15).

3   Working within the particularities of the KTP collaborative structure meant meeting on a regular fortnightly basis to assess research progress, consider findings and propose new ideas. These meetings also established general policy development and ensured the successful coordination of the project as a whole.

4   I have defined this classification to facilitate the analysis. By painting, drawing and printmaking I mean artists that work mainly with the mediums of such disciplines; by makers I mean artists that work with

sculpture and installation; and by other media I mean artists that work in performance, film/video, mixed media, non-commercial photography, socially-engaged and community arts practices.

5   The interviews took place between June and September 2011 and the interviewees were: Russell Burn, Amy Gee, Dryden Goodwin, Eryka Isaak, Robin Mason, Clare Price, Fernando Palma Rodriguez, Franco La Russa, (Childers Street); John Hooper, David Lock, Brigid McLeer, Gareth Mason, (Copperfield Road); Jonathan Baldock (Fire Station); Jane Goodwin, Jon Hicks, Rebecca Stevenson, Isa Suarez (Galleria); Samson Kambalu, Yukako Shibata, Poppy Whatmore (Harrow Road); Neville Gabie, Kitty (Jum-Im) McLaughlin, Paul St George (Leven Road); Kathy Prendergast, Fiona Rae (Orsman Road); Chris Aldgate, Rob Kessler, Clare Qualmann, Anthony Whishaw (Robinson Road); Cesar Cornejo (Rowse Close); Jochen Holz (Rowse Close/Sugar House).

6   The average studio space in Warton House, the most recently developed Acme building, is 375ft² (35m²).

7   In 2010 the site with the oldest demographic was Carlew House and one of the youngest was Rowse Close—excluding the Fire Station which follows a five-year residency programme.

8   Five seminars were held during the 2010–2011 autumn and spring terms. The workshops with architecture students brought them together with fine art students who acted as clients of a hypothetical studio design commission. The Acme artists that participated were Tete de Alencar (Childers Street), Jack Duplock (Leven

Road), Eleanor Moreton (Leven Road) and Christy Symington (Childers Street).

9   The Glassyard Building in Stockwell is comprised of UAL student accommodation, professional artists' studios and the Associate Studio Programme; it houses a broad spectrum of experience from students to graduates to professional artists.

10  In addition to the above, Acme supports early career artists through a number of awards and residencies, see http://www.acme.org.uk/residencies (last accessed 24 February 2015). In the period 2010–2015 the average age of Acme tenants decreased and we have seen an increase in the number of younger artists occupying Acme's studios and joining the waiting list.

11  Acme's occupation rate in 2013 was 99.3 per cent and the October 2014 survey showed that 44 per cent of the artists that submitted the survey rented their studio in the last five years. 13 per cent first rented between six to ten years ago; 12 per cent between 11–15 years ago; 11 per cent between 16–20 years ago and lastly 20 per cent more than 20 years ago. The data also showed that 48 per cent of the artists "strongly agree" and 37 per cent "agree" with the statement "Acme contributes to the development of my work by providing studios which are well designed and managed."

12  artfacts.net suggests that an artist's career depends very much on the market success of his or her exhibitions. It was not, however, the point of this research to give value to such a statement.

13  When applying for an Acme studio, artists are required to submit a CV to demonstrate that they have an active practice. However, for the purpose of an Arts Council England report, in a survey launched in October 2014, we included a section titled "Your work and making it public" where artists choose to record data such as the amount of shows and sales they have had in the last two years.

14  The selection of interviewees included regularly exhibiting artists—those considered successful in a commercial sense and those still establishing their career; tenants that had retired; were nomadic; single parents; disabled. There were 17 men and 14 women, and ages ranged between 23 and 85.

15  Oral history is a field of study and a method of gathering, preserving and interpreting the voices and memories of people, communities, and participants in past events.

16  A method used during these investigations could be defined as "design ethnography", which combines human-centred methods with ethnographic techniques, giving the researcher access to the users' world. My expertise (from my PhD) focuses on the use of ethnographic methods ie fieldwork study and participant/observer methods.

17  Recorded with a Marantz sound recorder, the RAW files are now accessible and stored in the Acme archive.

18  Often through the expression "in conversation with".

19  This is part of the *Documents of Contemporary Art* series published by Whitechapel Gallery and The MIT Press.

20  Buren starts the revision of "The Function of the Studio" with the sentence: "The function of the studio is absolutely, basically, the same as it always was." Buren, Daniel, "The Function of the Studio Revisited: Daniel Buren in Conversation", in Hoffman, Jens and Christina Kennedy, ed, *The Studio*, Dublin: Dublin City Gallery Hugh Lane, 2006, p 103.

21  The various managing body's mission statements are articulated on their websites.

22  Davidts, Wouter and Kim Paice, ed, *The Fall of the Studio: Artists at Work*, Amsterdam: Valiz, 2009, p 9.

23  Photographs by Glendinning and Moz Bulbeck are now part of the Acme archive, Acme Studios (Copperfield Road). A selection of the Acme archive was exhibited in the Pat Matthews Gallery at the Whitechapel Gallery as part of the show Supporting Artists: Acme's First Decade (1972–1982) between September 2014 and February 2014. The Acme archive can be accessed by appointment at Acme Studios, 44 Copperfield Road, E3 4RR, London.

24  The photographed studios at Childers Street were 78, Russell Burn; 79, Yoav Ben-David and Holly Stevenson; 80, Sophie Carapetian and Benjamin Osterberg; 81, Christopher Greene; 82, Sungfeel Yun; 83, Douglas Allsop; 88, Jeremiah Flynn and Karen Gregory; 89, Tim Garwood; 90, Sean Dower; 91, Eryka Isaak; 92, Corinna Till; 99, Sarah Poots; 100, Rose Davey; 101, Amy Gee; and 103, Jonathan Parsons. This essay is accompanied by images of Studio 80.

25  Changes in charity law, which have yet to be implemented, meant that in future Acme could be required to demonstrate with data that their tenants are "in necessitous circumstances" ie unable to afford to rent a studio on the open market.

26  The survey was completed by 42 per cent of Acme tenants. This is intended to be a two-yearly survey.

27  In July 2014 I was appointed Research Officer at Acme Studios and still actively participate in these meetings.

28  The project was presented at the Knowledge Exchange discussion organised by A New Direction in KTP partnerships, Birkbeck University, 2011; at the 'Future Space' event organised by the National Federation of Artists' Studio Providers, Birmingham, 2010; a research symposium convened by Sheffield Hallam University, Royal Holloway, University of London and DomoBaal Contemporary Art, 2011; the symposium The Art of Regeneration: Artists' Studios and their role in the city, organised by NLA (New London Architecture) at the Greater London Assembly, 2011; and at the International Art Professionals Summer School in Brussels, 2011. It has been featured in the Institute of Knowledge Transfer Exchange publication, spring/summer 2011, p 12; Arts Professional publication, no 237, p 23; "Creative Partnerships: Intersections between the arts, culture and other sectors", International Federation of Arts Councils and Cultural Agencies (IFACCA), 2011 report; and cited in Geliot, Emma, "Future Space", *Arts Professional Magazine*, 2011. See http://www.artsprofessional. co.uk/magazine/article/future-space (last accessed 24 February 2015). In November 2012 two presentations about the collaboration were made in Japan. One by Jonathan Harvey at 3331 Arts Chiyoda in Tokyo, and a second by Graham Ellard and Julia Lancaster (Acme Studios) at Aichi Prefectural Arts Centre, Nagoya, as part of the Aichi Triennale School. The collaboration was also presented by Graham Ellard as part of a one-day symposium Art School Futures at Tokyo University of the Arts (Tokyo Geidai) in November 2013. Other public outcomes are the publication of the paper "The Form and Function of the Artist Studio. A Pioneering Fine Art Knowledge Transfer Partnership Project Developed by Acme Studios and Central Saint Martins College of Art", *The International Journal of Arts in Society*, vol 7, no 4, 2014; the second prize in the 2012 KTP National award and the shortlisting for the KTP Knowledge Base Award 2014.

# EVERYTHING IS WORK: THE STUDIO AS ARCHIVE OF LIVED PRACTICE

HUGO GLENDINNING

4

In June 2011 Hugo Glendinning was commissioned to document 31 artist tenants and their studios. The 31 artists were selected as representative of the range of spaces and artists that Acme Studios supports, and it was these artists that also took part in the recorded interviews. The photographs were commissioned, like the interviews, for research purposes as part of the KTP collaborative project between Acme and Central Saint Martins. The following selection, which includes only one image of each artist's studio from the many taken, suggests the myriad forms the studio takes and ways in which it can be depicted while maintaining Glendinning's singular approach:

Amy Gee (Childers Street, SE8), p 70
Anthony Whishaw (Robinson Road, E2), p 71
Brigid McLeer (Copperfield Road, E3), p 72
Chris Aldgate (Robinson Road, E2), p 73
Cesar Cornejo (Rowse Close, E15), p 74
Clare Price (Childers Street, SE8), p 75
Clare Qualmann (Robinson Road, E2), p 76
David Lock (Copperfield Road, E3), p 77
Dryden Goodwin (Childers Street, SE8), p 78
Eryka Isaak (Childers Street, SE8), p 79
Franco La Russa (Childers Street, SE8), p 80
Fernando Palma Rodriguez (Childers Street, SE8), p 81
Fiona Rae (Orsman Road, N1), p 82
Gareth Mason (Copperfield Road, E3), p 83
Isa Suarez (Galleria, SE15), p 84
Jane Goodwin (Galleria, SE15), p 85
Jochen Holz (Rowse Close, E15), p 86
John Hooper (Copperfield Road, E3), p 87
Jon Hicks (Galleria, SE15), p 88
Jonathan Baldock (Fire Station, E14), p 89
Kathy Prendergast (Orsman Road, N1), p 90
Kitty (Jum-Im) McLaughlin (Leven Road, E14), p 91
Neville Gabie (Leven Road, E14), p 92
Paul St George (Leven Road, E14), p 93
Poppy Whatmore (Harrow Road, NW10), p 94
Rebecca Stevenson (Galleria, SE15), p 95
Rob Kesseler (Robinson Road, E2), p 96
Robin Mason (Childers Street, SE8), p 97
Russell Burn (Childers Street, SE8), p 98
Samson Kambalu (Harrow Road, NW10), p 99
Yukako Shibata (Harrow Road, NW10), p 100

**About twenty years ago** the *Sunday Times Magazine* asked me to make a portrait of Frank Auerbach and I arranged to meet him at his studio in Camden Town. The studio was top lit, with the patina of years of Auerbach's work with oil paint evident on every surface. It was another work, not only an impasto accident or by-product of a very particular painterly technique, but also evidence of the thousands of hours spent making marks and moving paint from tube to pallet to canvas. Here paint is sacrificed to floor, wall and table—the paint that never arrived in a work, making that other work that is the evolving studio. Auerbach did not want his studio to be seen, telling me that he hated the way that at some moment in the 1970s his studio had become a kind of theatre in which photographers and writers would site the artist. He wanted his studio to be private again, not a noisy public display, not a place for exhibitionism. We walked around Camden taking pictures for an hour or so before returning to the studio where the light that falls on the paint fell again on Frank. I asked if I could do one more portrait there in the space where the work happens, using only the light and the air of the studio, promising that the studio would not be visible or at least so out of focus that all architecture and every mark would be blown away by the ultra shallow depth of field afforded by the plate camera. He acquiesced and the portrait was made, a double-page spread image of the artist as the work.

This experience with Auerbach has informed the work I have been doing with Acme, looking at how artists use and inhabit their studios. It is as if this moment 20 years ago is the negative or inverse of the kind of revelation I am asking of the artists I visit in Copperfield Road, Robinson Road or Childers Street. Trying to imagine an artist's practice from space and residue, trying to get at how place can influence every tiny detail of work, and how material and movement generates art. The accumulation of time, human time and stuff. I try not to find drama, try not to bring assumptions, try not to add anything. Just try to see what might be important.

The figure of the solitary painter is one of the many versions of contemporary art practice that I have witnessed in my work with Acme and in the art world in general, while working with artists to both document and make their work. My own practice is one of intense collaboration with other artists. The work with the artists in this book is full of quick communication, transfers of trust and goodwill; most of all I hope it presents clearly and undemonstratively the two-way street of observation. They are all aware of me working as they themselves go about their work in the studio. This could be making tea, finishing a piece or reading a book. Everything is work. For many artists the studio is the universe in which thought and gesture both conscious and subliminal are corralled and collected; whether it be the split second of the framed world rendered by the camera or the slower layering and smearing of paint on canvas. The studio develops from initial occupation like a work, like a proxy practice that reveals as much about the actual work as it does about the artists and the space.

The empty studio offers potential and there are artists who need to hold on to that potential, keep the space clean and clear so that the work can come into the world uncontaminated by the immediate context. Often it is in these clean spaces that the smallest gesture can seem huge, guide marks on the wall, the choice of table or coverings used for light and windows. More often the accumulation of material, images and cuttings, shoes and other art, guides the eye through an archive of lived practice and possibilities, which in the end does indeed point to the singularity of the artist's vision. My work here was to trace these acts and affects without interpretation. As far as I could I tried to let the camera do the work. It was the mode of a forensic photographer, where seeing is tied to investigation, where one photograph can only ever be a clue, part of a larger picture.

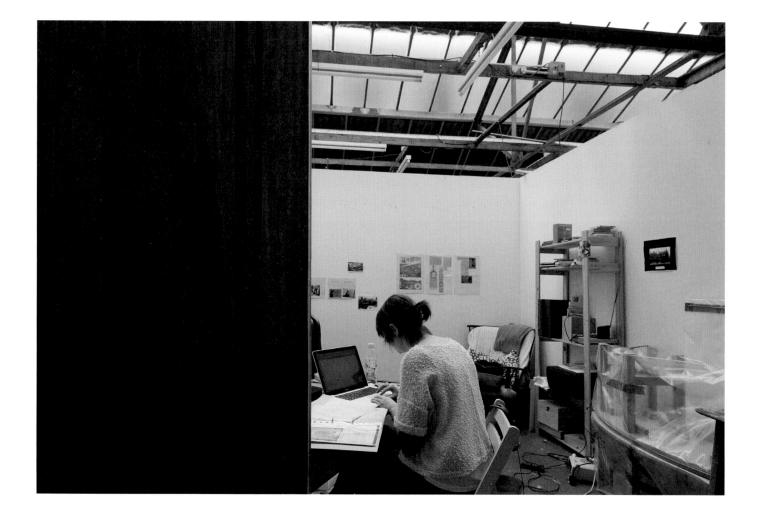

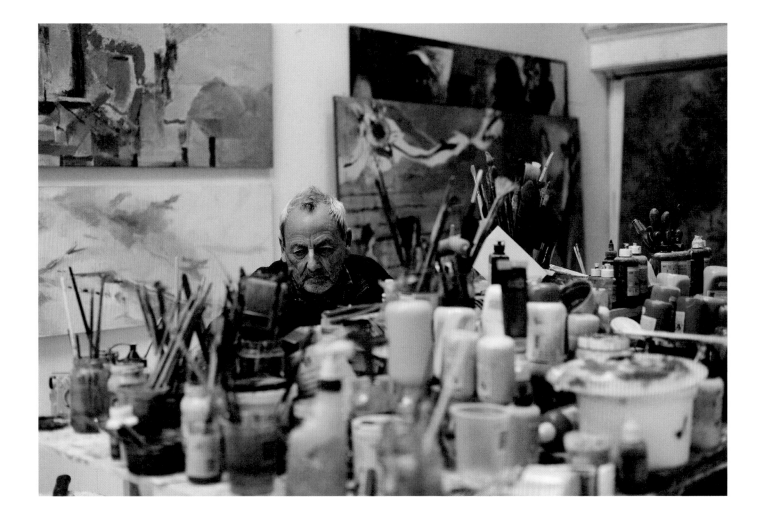

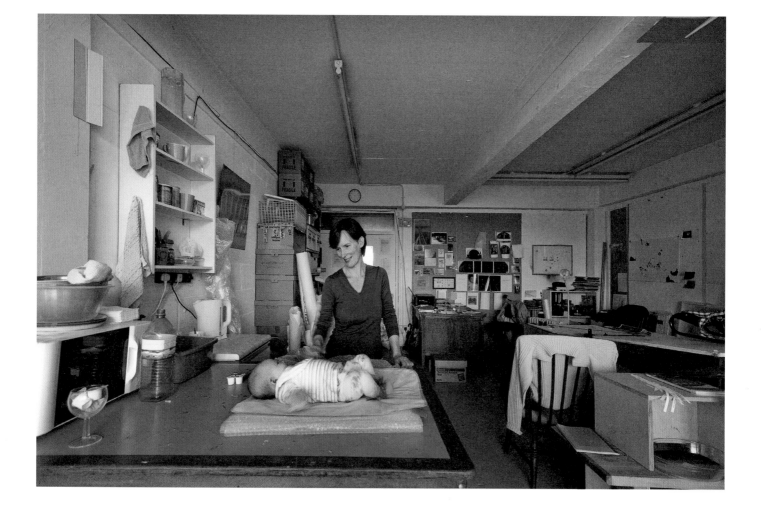

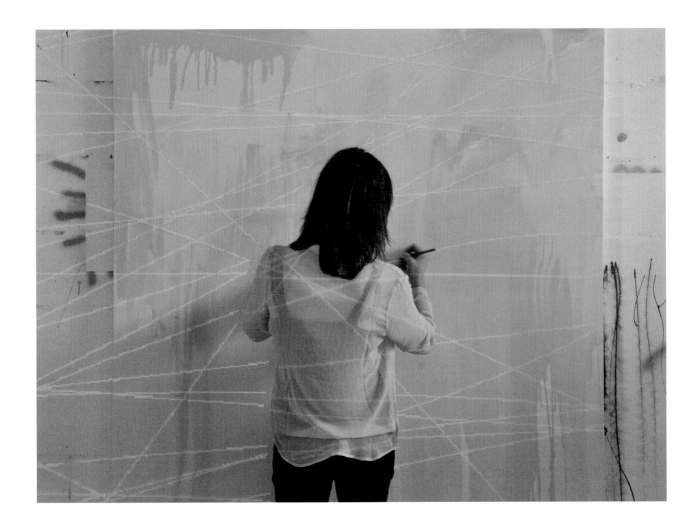

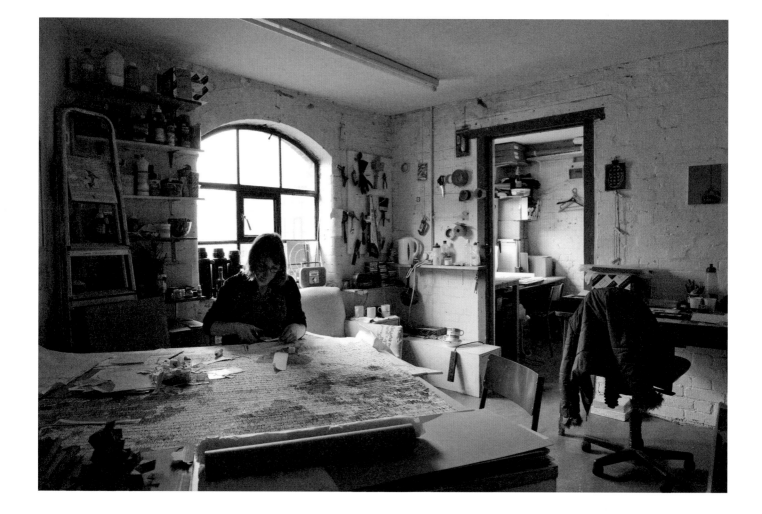

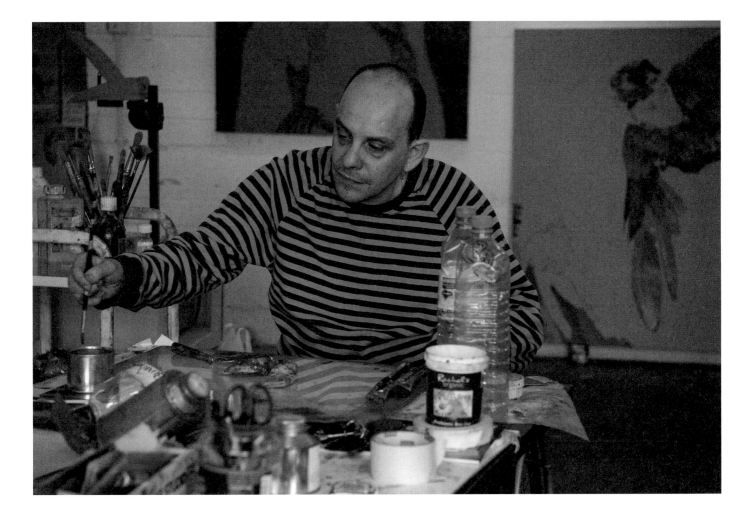

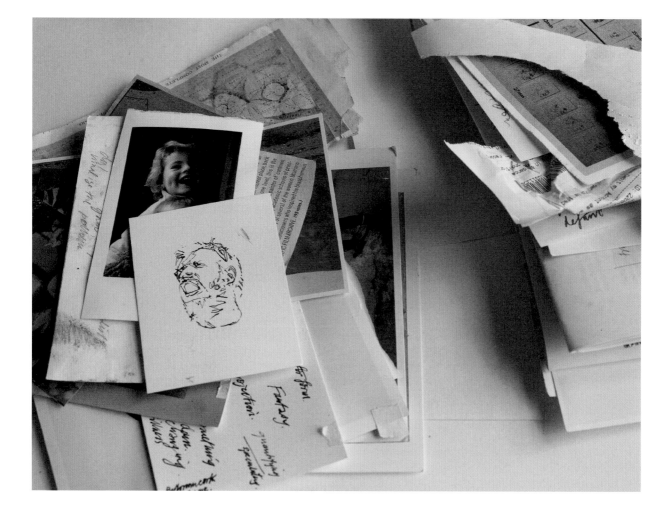

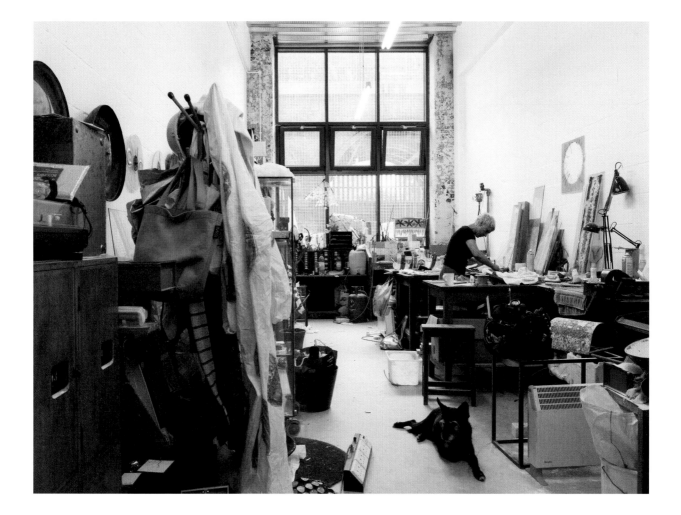

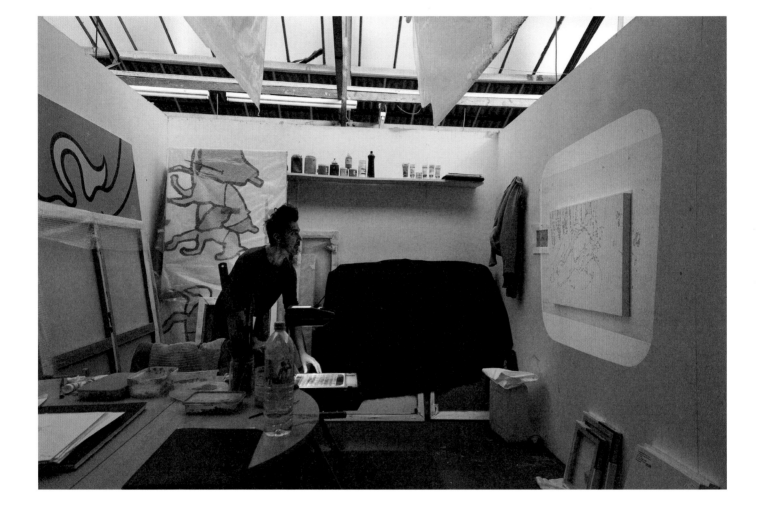

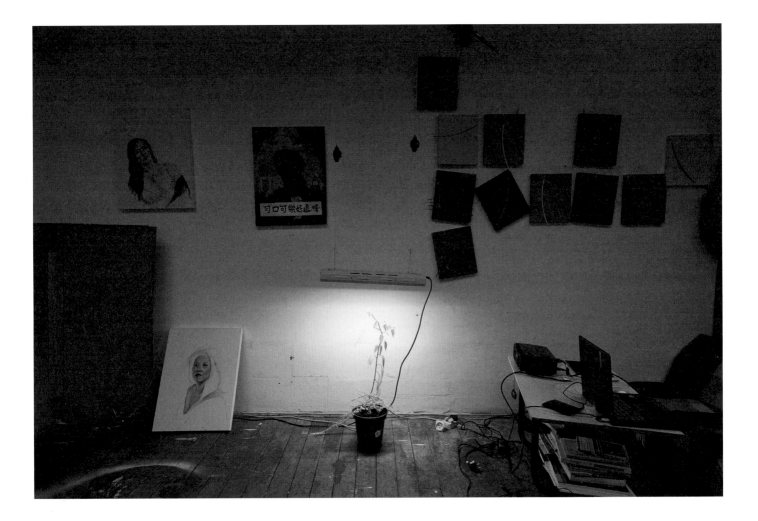

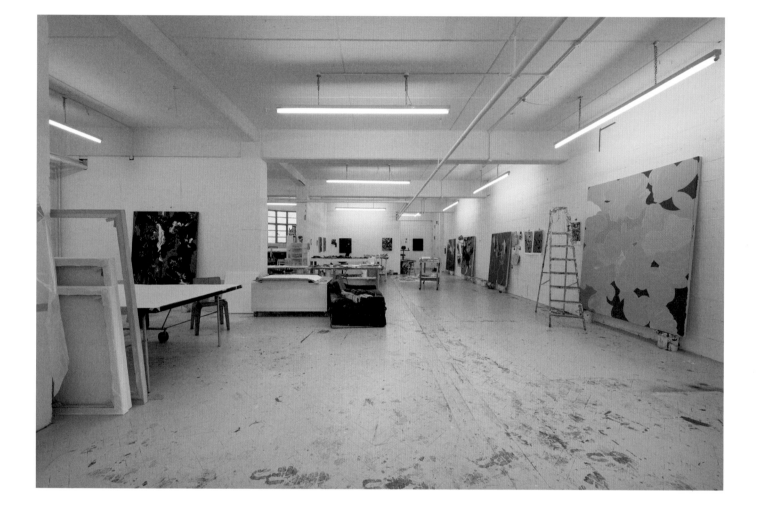

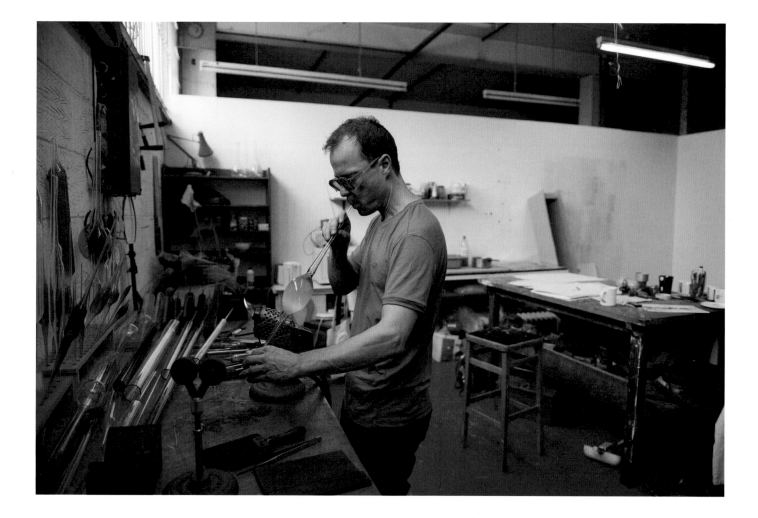

# THE ARCHITECTURE
# OF UTILITY

HAT PROJECTS

5

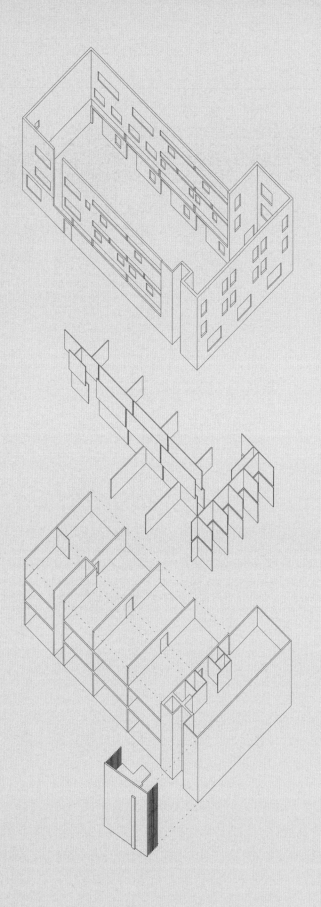

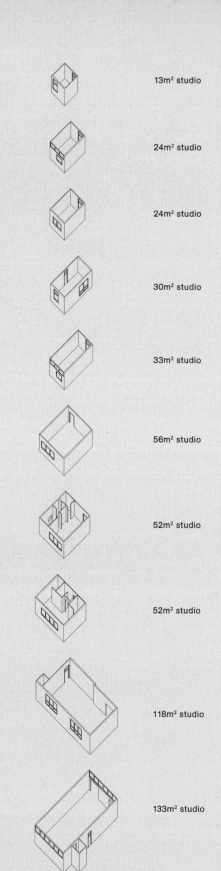

13m² studio

24m² studio

24m² studio

30m² studio

33m² studio

56m² studio

52m² studio

52m² studio

118m² studio

133m² studio

**top** Cladding and windows: brick skin over structural masonry substrate and aluminium cladding on timber for non-loadbearing infill.

**middle** Lightweight partitioning creates varied unit sizes within a structural grid.

**Bottom** Masonry structure: loadbearing concrete block and precase concrete planks.

**When we were interviewed** for the commission to design High House Artists' Studios we wanted to show some images of possible references for the future building's architecture. This proved difficult as there was no real precedent for this project: a stand-alone purpose-built artists' studio provision, to be let at affordable rents (not for residencies, not including gallery space, no cafe, not for a specific artist or artistic discipline) is a rarity in the UK and indeed abroad. There are only two comparable British examples, or possibly only one if we are being strict, so we fell back on presenting some art school spaces—from the Bauhaus, Dessau to the Royal College of Art's Sackler Building—as at least having some relevance.[1]

With most building typologies, the architect tends to be engaged—willingly or not—in a dialogue with how buildings "like that" are "supposed" to look. Houses are designed in sympathy or opposition to the various standard forms that we are familiar with, offices likewise. A community centre, or school, or health centre—even when there is an innovation in terms of the actual function or combination of functions that are provided—contend with some kind of folk memory of how a public building might look that coalesces together all the examples that have been experienced into a loose set of architectural tropes.

With artists' studios, almost all our folk stereotypes are of buildings that were not intended for that purpose. Artists—as the regeneration textbooks repeat—are colonisers, taking over buildings after their intended use has disappeared, whether residential (unwanted housing stock) industrial (warehouses and factories), institutional (old town halls and fire stations) or agricultural (barns, stable blocks, silos). Acme Studios' history encompasses all of these (apart from the rural), with the more recent addition of a form of purpose-built block that is equally restricted or compromised—undertaken by residential developers as a way to satisfy planning requirements for a mix of uses on the site—where the studios are subsumed within a corporate architectural approach.

We were therefore in the privileged and challenging position of developing a new typology virtually from scratch, and one with very strict confines in terms of budget and brief. It was perhaps fortunate that Acme's research with artists, as pursued through the Knowledge Transfer Partnership with Central Saint Martins, indicated that a highly anonymous building—private, undecorative, a kind of anti-architecture, by some people's reckoning—was preferred to a demonstrative expression that advertised the creative activity within. The brief was not for a 'beautiful' building, but one that was robust, flexible, inexpensive and met fairly precise requirements for '"daylighting" and studio sizes. It required a kind of total design thinking about every aspect—a careful integration of business model, structure, materials and services thought through from first principles—that was more akin to a product design challenge than one that was explicitly architectural.

The completed studio building is unashamed in its use of low-cost and robust materials but the process of their selection was not made without thought. We chose common fletton bricks, which are not only low-cost but also have an appealing visual irregularity and recall the industrial buildings of the early and mid-twentieth century. We 'saved' on the cost of the main stairwell by pushing it outside the weatherproofed, insulated envelope of the building, but it is leant a sense of quality through its generous geometry and the use of timber for its screening and handrails. It allows every user of the building to experience the extraordinary view out over the working river basin, while going to and from their studio.

High House Artists' Studios RM19
Sectioned drawing
HAT Projects

The utilitarian look of the building—and the associated low cost of the construction, leading to low rents for artists—would not be possible in an area that is more conservative in terms of its surrounding context, requiring a more subtle, and therefore expensive, architecture. For us, this is a fascinating aspect of this project as it suggests the suitability of the affordable studios typology for edgelands such as Thurrock, where huge industrial sheds rub up against low-quality housing, motorways and scrubland. We are sentimental about the idea that artists inhabit the inner city, but the build costs—let alone the land prices—in these areas would force rents higher, at least under the business model of this project.

In the search for affordable studio space, and as the competitive market eats up suitable existing buildings, we feel that this model has the potential to be adapted to many other sites in similar locations, not just for artists, but for startups and small businesses of many kinds. Providing high-quality, robust, but very basic shell space—without the ceiling tiles and downlighters of a conventional business park or office development—is more affordable and thus presents less financial risk to the developer (whether a local authority, social enterprise or commercial developer), as well as lower rentals for the occupiers. Much as the freezing garret or warehouse may hold romance, it must also be good to provide warm, secure space that is cheap to heat and light. We relished the opportunity to develop this project with Acme and High House Production Park, we are proud of the built form and the quality of the studio spaces within it, and we were delighted to bring it in under budget, at £78/ft$^2$ (£836/m$^2$). We learnt a great deal and we are already applying those lessons to our current projects.

*Hana Loftus, HAT Projects.*

Notes

1   The two comparable British examples are ACAVA's
    Blechynden Street Studios, London and Yorkshire
    Artspace's Persistence Works Studios in Sheffield,
    but Persistence Works Studios includes other uses in
    addition to studio space.

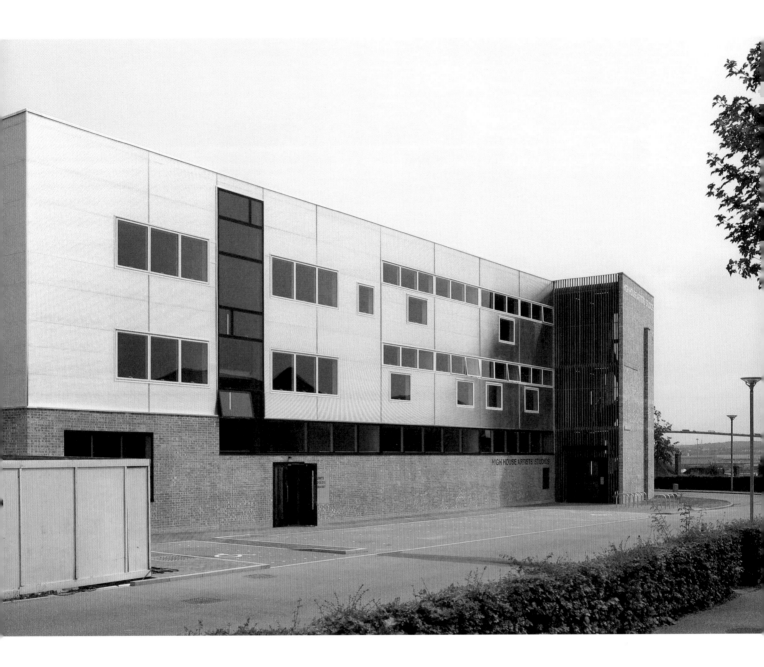

High House Artists' Studios RM19
Photograph: HAT Projects, 2013

(top left and right) High House Artists' Studios  RM19
Photographs: HAT Projects, 2013

(Bottom left) High House Artists' Studios  RM19
Photograph: Hugo Glendinning, 2014

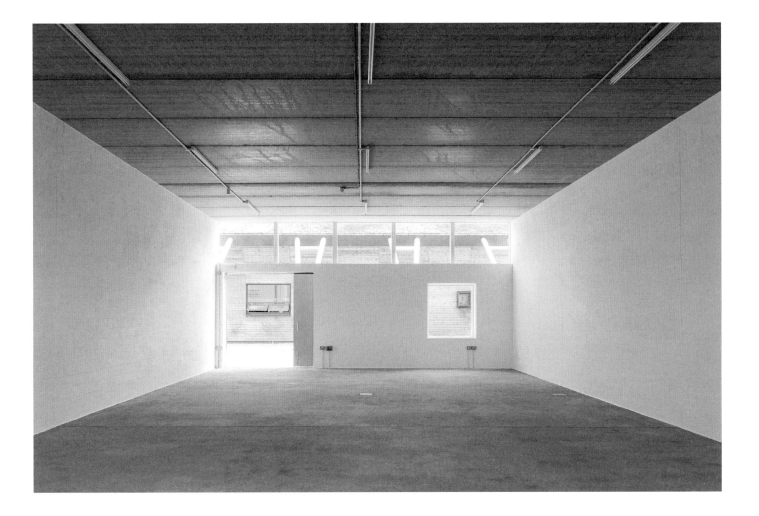

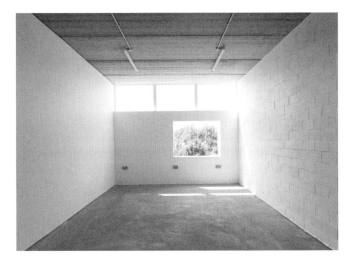

High House Artists' Studios RM19
Photographs: Hugo Glendinning, 2013

High House Artists' Studios RM19
Photograph: Hugo Glendinning, 2013

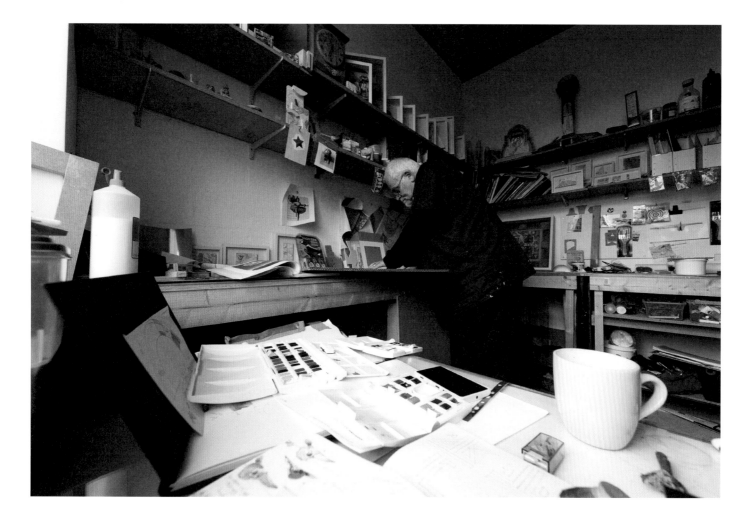

High House Artists' Studios  RM19
John Espin in his studio
Photograph: Hugo Glendinning, 2014

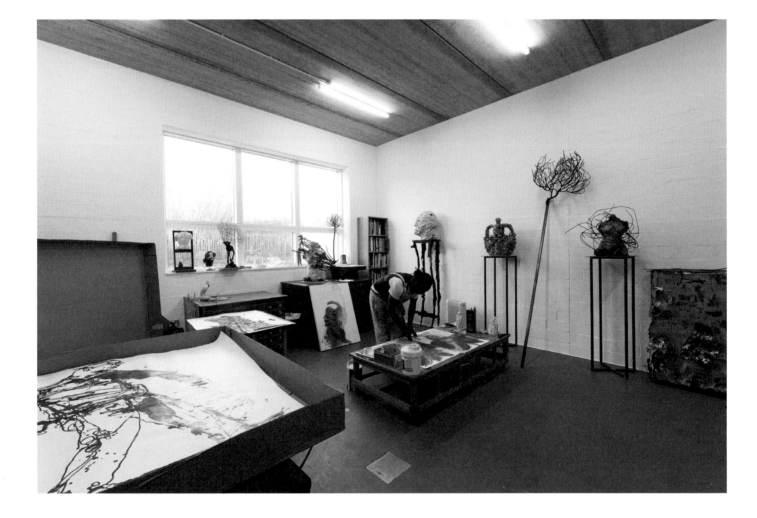

High House Artists' Studios  RM19
Everton Wright in his studio
Photograph: Hugo Glendinning, 2014

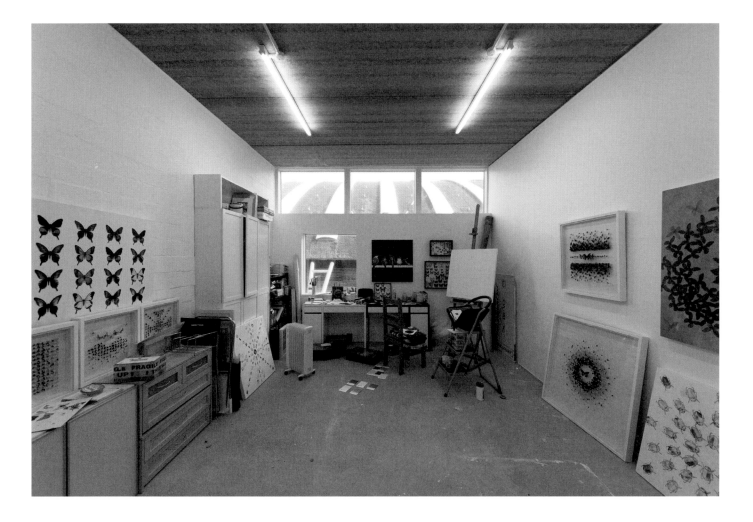

High House Artists' Studios  RM19
Anna Masters' studio
Photograph: Hugo Glendinning, 2014

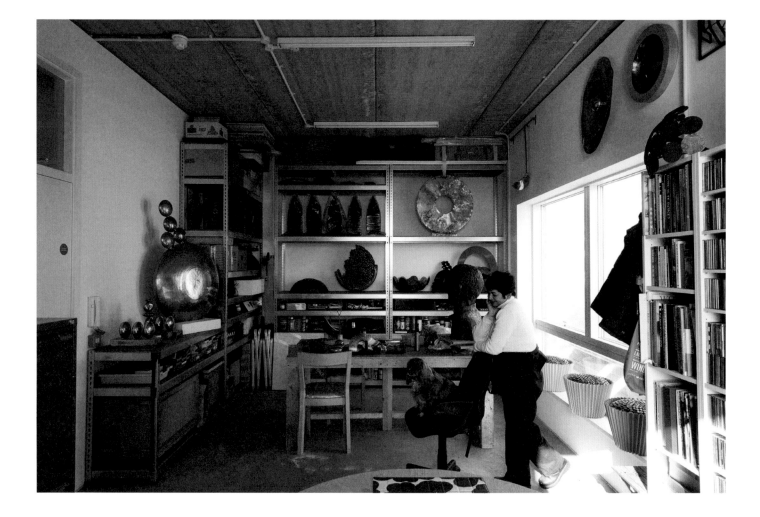

<u>High House Artists' Studios</u> RM19
Lata Upadhyaya in her studio
Photograph: Hugo Glendinning, 2014

**High House Production Park**

High House Production Park is the result of a long-term collaboration between the Royal Opera House, Creative & Cultural Skills, Acme Studios, Thurrock Council and Arts Council England, together with the departments of Business Innovation and Skills, Communities and Local Government and their agencies.

Thurrock Thames Gateway Development Corporation, the agency responsible for the delivery of the project was merged into Thurrock Council in April 2012, and High House Production Park Ltd, formerly a subsidiary of TTGDC, is the charity which now operates the Park.

The first phase of development of the 14 acre site, its heritage buildings and public park, was completed in 2010 with the opening of the Royal Opera House Bob and Tamar Manoukian Production Workshop. This was followed in early 2013 by the launch of Creative & Cultural Skills Backstage Centre, a world-class production, rehearsal and training venue for performance, broadcast and live events and in July 2013 Acme Studios opened High House Artists' Studios, a new building that responds to in-depth research into the design and performance of artists' studio space. The latest phase of development saw the arrival of the Royal Opera House Bob and Tamar Manoukian Costume Centre which opened in March 2015. As well as the storage and making of costumes for Royal Opera House productions, there will be permanent workrooms specifically for students, with opportunities for training with the Royal Opera House. Announced in December 2014, the first government backed National College for the Creative and Cultural Industries is to be established at the Backstage Centre, opening in September 2016.

**Background**

Prior to the development of High House Production Park, arts and culture were not a strategic priority for Thurrock Council. There was very little infrastructure or professional expertise to generate major opportunities and resources for high-quality cultural experiences. There was an arts officer, a heritage officer, and a small civic cultural centre, as well as amateur and voluntary sector activity organised around its members' enthusiasms. However, things began to change around 2007. Local ambition was effectively brokered, and the future reimagined through a bold shared vision of the creative sector shaping and leading the delivery of strategic priorities central to the area's health and prosperity. High House Production Park was effectively the 'game changer' project. Even though this sort of venture had not happened before, its purpose, scale and ambition attracted major investment. It was the quality of the idea that attracted people; seeking an ambitious alternative was the rational thing to do as the status quo was not working well for communities in Thurrock.

Now the collective leadership of the partners of High House Production Park works as part of the wider collective leadership of Thurrock as a place. In 2013, with expert advice from High House Production Park, Thurrock Council agreed a statement of its strategic priorities for arts and culture called "Unleashing Creative Ambition", and the South East Local Enterprise Partnership adopted the creative industries as a priority sector in its "Strategic Economic Plan". High House Production Park Ltd is committed to securing the partners' vision for the Park as a self-sustaining world-class centre of excellence for creative and cultural production which will lead the wider regeneration of the area.

*High House Production Park, March 2015*

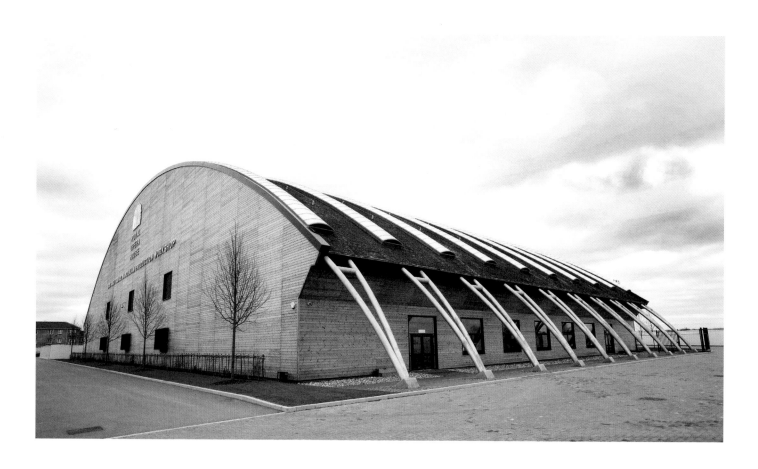

(top)
High House Production Park  RM19
Barns
Photograph: Rob Moore, 2010

(bottom)
High House Production Park  RM19
Royal Opera House's Bob and Tamar
Manoukian Production Workshop
Photograph: James Fletcher, 2010

High House Production Park  RM19
Gardens and view
Photograph: James Fletcher, 2013

High House Production Park  RM19
Creative & Cultural Skills' Backstage Centre
Photograph: James Fletcher, 2013

# FUTURE

# COLLABORATIONS

GRAHAM ELLARD AND JONATHAN HARVEY

6

**At the close of this book** it is worth emphasising the crucial and defining features of the partnership behind the activities we've discussed here. As the introduction described, this is a collaboration that has a history, and as such represents a substantial, committed and long-standing relationship between two very different organisations connected by a common investment in, and responsibility towards, emergent and established artists. Of utmost importance, however, is the fact that this collaboration is an ongoing one.

The Knowledge Transfer Partnership was formally completed in January 2013. It was structured around its original objectives but during its lifespan (effectively extended by six months) a number of enormously valuable opportunities to apply the project's research emerged—notable amongst them are High House Artists' Studios and the Associate Studio Programme at the Glassyard Building. As a result, the momentum of these projects carried us seamlessly beyond the formal conclusion of the KTP into an ongoing collaboration, with regular meetings continuing without pause or interruption.

In many respects this is one of the key achievements of the project—the creation of this ongoing partnership, as the basis on which to devise future projects or respond to new opportunities as they present themselves or can be initiated.

High House Artists' Studios has been discussed in detail elsewhere. In this chapter we would like to say a little more about the Associate Studio Programme, since it's perhaps through the Associate Studio Programme at the Glassyard that the partnership most obviously expresses the shared interests of both Acme and CSM. Furthermore, it's the model developed at the Glassyard—a model which is, crucially, sustainable, portable and scalable—that provides the template for further, future developments at other sites. And this is exactly what we are now doing with a second new University of the Arts London Hall of Residence building, currently under construction at Elephant and Castle in South London, and planned to incorporate an Associate Studio Programme for 12 more graduates from CSM.

What follows isn't intended as a conclusion to this book, but as a summary of an initiative that brilliantly represents the open-ended nature of the partnership—with its roots in conversations as far back as 2008—and its potential for the future.

### The Associate Studio Programme

As has been made clear through the preceding chapters the Acme/CSM collaboration is based on an understanding, from each of our differing but complementary perspectives, of the complex landscape and the patterns of practice relevant to how the provision of studio space can best meet the needs of artists today. For CSM the key issue has been the immediate experience on graduation and how the student experience at art school prepares them for the realities and challenges of practice in London. This has led us to ask questions of the received image of the studio (one which despite enormous changes in the ways artists practice remains largely unchanged and typically exclusive and private). It has prompted us to look very closely at the studio's material and immaterial functions, the historical received model and departures from it, and how meaningful (or not) this is for students in their perception of their needs on graduation. For Acme the central issue is how its provision currently meets those needs, and can continue to do so in the future.

The project identified numerous, significant design considerations determining the use of the studio space through its layout, material construction and fixtures. But it also identified a

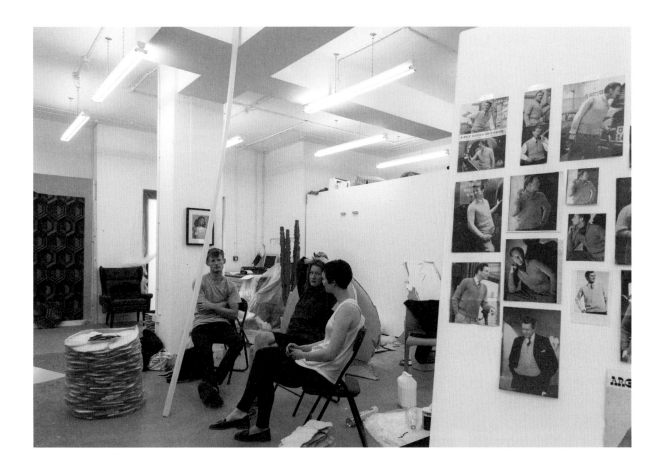

number of equally significant immaterial or contextual considerations. One of these became apparent by looking closely at the profiles of all of Acme's existing tenants where we saw that the average age was 45 and from the data and monitoring forms, it appeared that there were few artists under 30 both in Acme's studios and on the waiting list. This has changed significantly in the last two to three years. But it did suggest, in general terms, and based on some reasonable assumptions regarding age, that there was a clear 'gap' in the years immediately out of college with recent graduates under-represented both in Acme's studios and on the waiting list.

This was clearly a question worth pursuing, and became one of the many ideas explored through the series of seminars and workshops with undergraduate and postgraduate students at CSM. It became apparent that while the cost of a studio might be the most obvious issue it wasn't the only one. As one student explained—the idea of stepping into a big studio of their own (even if they could afford it) and hearing the door slam behind them was actually terrifying! The students anticipated that they would find a sense of community or cooperative culture, which was so important to them as students, to be more valuable than a large self-contained studio space of their own.

What we could then begin to see was that the cooperative, collaborative use of space, and the sense of community it might inspire, may be desirable (or even for many an ideal) but is something that depends on a context, such as a college course, to bring those people together in the first instance, out of which a community can develop. After graduation the context is

Glassyard SW9
Artists in the Associate
Studio Programme space
Photograph: Hugo Glendinning, 2014

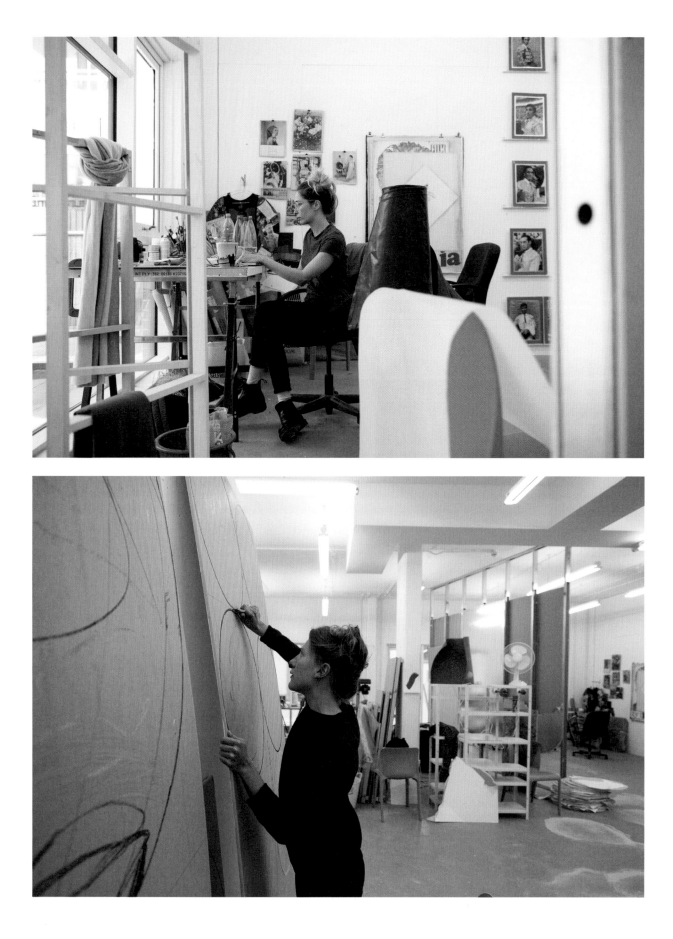

very different and the considered construction or membership of an identifiable community is removed. Within Acme's core activity the creation and management of such a community isn't feasible. For Acme, CSM offers a route into a pre-existing community, while for CSM, Acme offers the means to provide high-quality and highly-affordable space in which its graduates can develop their professional practice.

In 2011, the developer Spiritbond approached Acme about the potential for creating affordable artists' studios as part of a larger development in Stockwell Green in South London. The planning authority, Lambeth, had required the inclusion of affordable workspace within the larger scheme and Spiritbond was aware of the "planning-gain" projects that Acme had successfully achieved with other commercial and social housing developers. Unknown to Acme at this early stage was that the main development was for student accommodation being undertaken for University of the Arts London, but it soon became clear that UAL's knowledge of Acme's work had led to the approach to the organisation by the developer. The future co-occupation of the building by students from UAL (as residential accommodation) and by professional artists from Acme (as studio space) immediately suggested enormous potential for collaborative working.

The student accommodation development, which became known as the Glassyard Building and which opened in October 2013, is composed of 328 bedrooms and studio flats of which 258 are reserved for use by UAL. Acme has 24 ground and lower ground floor studios including one very large studio of 1,300ft$^2$ (121m$^2$), and we saw this as an ideal space in which to create a shared 'transitional' studio space for recent graduates of CSM's BA Fine Art course — 'transitional' in that it aims to support their practices during the particularly difficult first few years after college. The CSM Associate Studio Programme, as it was to become, provides a supportive environment without simply extending the 'comfort zone' of the college experience. The emphasis is on the creation of a mixed but cooperative community of emerging artists, who, at the point of joining the scheme, have already made a commitment to continuing a professional practice. On this basis the scheme provides a very affordable route into a professional studio space in a mutually supportive environment and is underpinned by a programme of collective dialogue and mentoring involving visits by professional artists, curators and academics.[1]

The programme offers a new-build, accessible, secure and self-contained ground floor shared space for a group of eight graduates from BA Fine Art at CSM, for two years. This space is located within the larger studio development and built to a high specification, with natural light, 3m high ceilings, lighting, power, heating and WiFi.

Rent is set at half Acme's average rate meaning that the rent for each artist is approximately £20 per week. The programme was announced in May 2013 and applications invited from the graduating BA Fine Art cohort and the previous year's graduates. After interviews in June, eight graduates were selected and they moved in on 1 October 2013.[2] They have since approached the scheme with extraordinary enthusiasm as an entirely collective, cooperative endeavour and have organised the space themselves, with funding from CSM and Acme, as an open-plan studio, with no physically separated spaces, and supporting a range of practices.

The scheme doesn't allow CSM to escape the challenges it faces in maintaining (let alone expanding) the studio space available in the college. But it has provided the basis for deliberate research and examination of what it is doing in response, how it can better substantiate the case made for space, and how that can extend the support it provides to students after their graduation.

(top) Glassyard SW9
Tilly Shiner in the Associate
Studio Programme space
Photograph: Hugo Glendinning, 2014

(bottom) Glassyard SW9
Asta Meldal Lynge in the Associate
Studio Programme space
Photograph: Hugo Glendinning, 2014

The Associate Studio Programme is the first scheme of its kind in London, and represents a very important experimental initiative for an art school and a studio provider to undertake. For CSM its significance is in the way it materially extends the school's relationship with its students into the world of professional practice and reinforces the role of the art school and what it makes possible. For Acme it is a bold and proactive step to further its support for graduates or emerging artists, and address the difficulties faced by that key group in the first years of their careers. More generally it represents an example of two organisations working together to create something that despite its importance or their desire to make it happen, neither could have done alone.

The enthusiasm of the eight artists at the Glassyard tells us that it does satisfy real needs. We look forward to seeing their ambitions develop there, as they work through for themselves what a studio might be.

Notes

1   To date studio visits have been made by Stephen
    Melville, Marie Lund, Adam Chodzko, Redmond
    Entwistle, Lisa Panting, Laura White, Lindsay Seers.
2   The 2013 Associates are Lydia Davies, Chris Ifould,
    Piotr Kryzmowski, Sean Lavelle, Asta Meldal Lynge,
    Cameron Scott, Tilly Shiner, Nikhil Vettukattil.

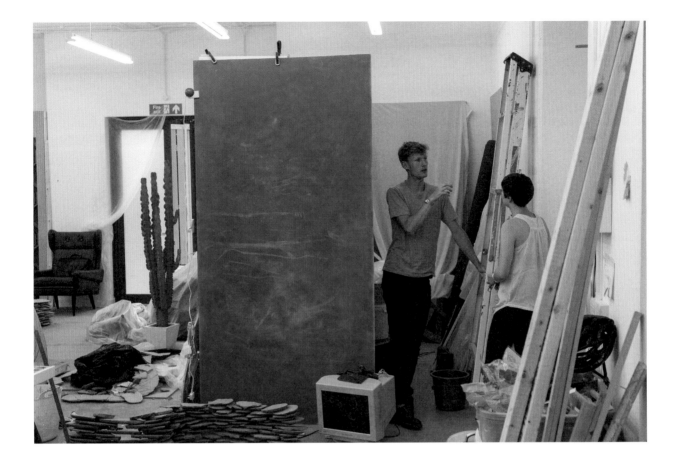

Glassyard SW9
Chris Ifould (left) and Lydia Davies
in the Associate Studio Programme space
Photograph: Hugo Glendinning, 2014

# AFTERWORDS
## JAN STRINGER

**KTP Regional Adviser, Innovate UK**

I am delighted to have been invited to add my perspective to this important publication on behalf of the Technology Strategy Board (now Innovate UK). I was one of the Knowledge Transfer Partnership Advisers supporting this project over its three years of development and delivery. The role of a KTP Adviser is to help the partners co-create the project and deliver it. We are involved in developing the KTP application and, once approved, we monitor and support progress throughout the life of the partnership.

It is fitting that the Knowledge Transfer Partnerships programme, a part government-funded scheme that was founded in 1975, just a few years after Acme Studios, has helped position the organisation to face the next 40 years of its history. Our aim was to ensure that all three parties, in this case Acme Studios, Arantxa Echarte (the Associate), and Central Saint Martins, University of the Arts London, maximised their benefits from participating—in both the shorter and longer term. It was my privilege to have been a coach and mentor to the Associate; to help her make the most of the collaboration and of the personal development opportunities that a KTP provides. The aim is to develop Associates into the potential business leaders of tomorrow that we need to take our UK businesses forward. Although I have advised on numerous KTP projects, this was the first fine art partnership to be supported by the programme. I am extremely impressed by what it has achieved and I consider it an exemplar of a KTP where all three partners are in the arts sector. It has the potential to make an important contribution to our cultural and creative economy through the embedding, in Acme, of the capacity to deliver highly "fit-for-purpose" studio facilities at an economic cost.

Originally aimed at engineering projects, the Knowledge Transfer Partnerships programme (and its predecessor, the Teaching Company Scheme) today covers a wide business spectrum to meet the social, technological and economic priorities of the UK. It facilitates a three-way partnership between a business, UK university or college (or research and technology organisation) and a recently qualified person (usually graduate or postgraduate), known as the Associate. It offers a company the chance to collaborate on a business opportunity, idea or innovation. The KTP Associate is based in the business to help gain the knowledge and capability it needs to innovate and grow, supported by the Academic team.

A KTP can vary in length from six months to three years, depending on the needs of the organisation and the desired outcomes. Government funding enables access to well-qualified people and experts within the UK's universities, colleges and research organisations who can also help to take businesses forward. The programme is UK-wide, headed by Innovate UK and supported by 12 other funding organisations including all of the research councils, the devolved administrations, Invest Northern Ireland, and other government departments. It is also Europe's leading programme aimed at helping businesses to improve their competitiveness, productivity and performance through the better use of the knowledge, technology and skills that are

available within the UK research base. The eligibility of any individual organisation to participate in a KTP is determined by the funding organisations' criteria for support. It fiercely defends its position as the 'gold standard' of knowledge exchange mechanisms; only the highest quality partnership proposals, such as this project, are supported.

The open mindedness with which this partnership approached the processes and structures that we bring was crucial. I feel it enabled them to get maximum benefit from both the project and the partnership, as well as to start a culture change in Acme that will form a strong basis for their future success. The partnership in general, and Arantxa in particular, really embraced the project management disciplines I advised on and it shows what an engineering-originated methodology can achieve when delivered by a very capable and creative individual. I also consider the study of literature on the subject of the studio, and its impact on the discussions held at Central Saint Martins, to have been highly valuable. The project enabled a new link between the Fine Art and Architecture courses, and the positive relationship between Acme and Central Saint Martins is reflected in ongoing projects including a newly-developed Associate Studio Programme for recent graduates.

High House Artists' Studios and the Associate Studio Programme at the Glassyard Building, both of which were developed during this KTP, leave fitting, and lasting, monuments to the relationship between Acme and Central Saint Martins. These are very innovative projects, both architecturally and socially. I have found it very rewarding to have been involved, in a small way, in contributing to this success.

I know I will continue to watch the ongoing achievements of the three partners for many years, both with interest and fondness.

# ROBERT KEEGAN

**Knowledge Exchange Portfolio Manager, Arts and Humanities Research Council (AHRC)**

In many ways the Knowledge Transfer Partnership between Acme Studios and Central Saint Martins has been a model project for the Arts and Humanities Research Council. The project focuses specifically on a key but somewhat hidden component of arts practice as well as on the creative economy more generally. In order to gain support a KTP proposal must demonstrate that it is innovative and of direct strategic relevance to the company and also that there is a clear need for input from the academic partner and a need for knowledge transfer. This partnership has exceeded expectations in these areas and has established a fruitful and longer-term collaboration from which all parties can benefit. This alone more than justifies our investment. However it has been the fusion of the partners' interests that really helped advance the project so successfully. What has been particularly impressive is the capacity of Acme not only to embed research and development as a new core activity, but also to embrace the unexpected, seize new opportunities and be open to challenge and creative self-reflection allowing them, as CEO Jonathan Harvey says, "to achieve a better understanding of who we are, what we do and why we do it". For Central Saint Martins the collaboration clearly reflects the college's proactive and far-sighted relationship to the worlds of professional practice that their students aspire to, and go on to play a significant part in.

This kind of transformational change is at the heart of AHRC's support for knowledge exchange and it has been 'exchange' and co-production rather than 'transfer' (transfer is a redundant term in the Arts and Humanities) with both partners working together and sharing their experience, knowledge, understanding and expertise to mutual benefit. This has manifested itself in both the physical 'improved product' and in the theoretical and technical understanding of the role of the studio in contemporary arts practice.

Through the KTP, Central Saint Martins has been able to apply the experience and expertise of its staff and students to a key component of professional practice and develop innovative models for supporting its graduates. Acme as a company has been able—and perhaps more importantly, willing—to change its practices and organisational culture to better meet the need of its clients. Those clients though are seen by the company as its beneficiaries and as a not-for-profit organisation, with 99 per cent occupancy rates, increased financial turnover is not a driving force, in fact it is the opposite. The cultural and societal benefits are obvious but can such investments contribute to wealth creation and economic growth in the UK? Innovate UK's new criterion for support might argue no, but as a supporter and funder of research and knowledge exchange in the creative economy the AHRC would argue it does, albeit in more oblique or less direct ways. Alongside the high-quality research and expertise in professional practice offered by institutions such as Central Saint Martins, the work that organisations such as Acme undertake and the services they provide are a critical part of underpinning creative practice in the UK.

The KTP and the robust engagement and dialogue with academia has resulted in new knowledge and understanding for all parties. This project has showcased how better design, service provision and more efficient ways of working based on a combination of co-produced research and user engagement can contribute significantly to the creative life of the UK, strengthening what is currently the fastest growing sector of the economy.

# PETER HESLIP

**Director, Visual Arts and London, Arts Council England**

Artists' studios in England appear to be under threat; a 2014 report commissioned by the Mayor of London estimated that approximately half of all studio spaces in the capital may be lost to redevelopment within the next decade. The question for the country therefore, not just the cultural sector, is how do we enable another generation of artists and creative practitioners to afford to work and live here, ensuring the best talent is attracted to and retained in England? If we do not act today we put at threat our historic position as an international creative powerhouse.

One way to respond to this threat is to develop a long-term, sustainable model for studios underpinned by a coordinated effort between government, the cultural sector and partners in higher education and business; this publication recognises and supports this model. High House Production Park in Thurrock is an example of what is possible through long-term collaboration. This project is a result of a coalition of Acme Studios, the Royal Opera House, Creative & Cultural Skills, Thurrock Thames Gateway Development Corporation, Thurrock Council and Arts Council England with support from the departments of Business Innovation and Skills, Communities and Local Government. The award winning High House Artists' Studios, developed on the Park, and a key subject of this publication, is a low-cost build and now fully let, offering a compelling business model for future developments.

Some of the best and brightest new studio solutions around the country are the product of partnerships with universities; University of the Arts London was involved in the development of both the studios at High House Production Park and Acme's Glassyard studios in Stockwell. This partnership evolved from Acme's Jonathan Harvey and Central Saint Martins' Graham Ellard's mutual interest in working conditions for art students after graduation. While university partnerships are increasingly important for our National Portfolio Organisations, formalised Knowledge Transfer Partnerships are still relatively rare with this the first-ever KTP based in the fine arts. The research-based approach to understanding the needs of future Acme artists and future-proofing this research model is likely to be of wider benefit to the studios sector. Acme's research recognises the continuum in an artist's career which runs from college to professional practice. The new studio buildings include the physical space for graduates which is complemented by Acme's ongoing relationship with universities and its delivery of graduate awards, and with CSM, associate schemes offering a direct mechanism to aid graduate transitions.

Arts Council England has enjoyed a long-standing partnership with Acme Studios and considers it a key agency for providing artists with affordable studio space in London. Its buildings estate is one of the largest, and most secure, and therefore Acme's success has a significant bearing on the livelihoods of so many artists. Arts Council England is particularly interested in the resilience of the cultural sector and over the years has made a number of strategic investments in Acme to enable it to become financially independent. It is testament to its success that Acme is one of the few organisations to "graduate out" of Arts Council England's portfolio of revenue funded organisations at the end of March 2015. One of the most promising outcomes of the KTP is Acme's decision to make the research process one of the organisation's permanent functions resulting in a unique capacity for business research and development and the potential to benefit the wider studio sector with a range of promising future initiatives.

Bibliography

Amirsadeghi, Hossein ed, *Sanctuary: Britain's Artists and their Studios*, London: Thames and Hudson in association with TransGlobe Publishing Limited, 2011

Amos, Robert, *Artists in Their Studios: Where Art Is Born*, British Columbia: TouchWood Editions, 2007

Beck, John and Matthew Cornford, *The ART SCHOOL and the CULTURE SHED,* Surrey: The Centre for Useless Splendour, 2014

Behrends, Rainer and Karl-Max Kober, *The Artist and his Studio*, London: JM Dent & Sons Ltd, 1973

Bellony-Rewald, Alice and Michael Peppiatt, *Imagination's Chamber: Artists and Studios*, Boston: Little, Brown and Co, 1982

Brickwood, Cathy, Bronac Ferran, David Garcia and Tim Putnam, ed, *(Un)common Ground: Creative Encounters across Sectors and Disciplines*, London: Bis publishers, 2007

Buren, Daniel, "The Function of the Studio Revisited; Daniel Buren in Conversation", in Hoffman, Jens and Christina Kennedy ed, *The Studio*, Dublin: Dublin City Gallery Hugh Lane, 2006

Buren, Daniel, "The Function of the Studio" (trans Thomas Repensek), *October*, vol 10, fall 1979, pp 51–58

Cole, Michael and Mary Pardo ed, *Inventions of the Studio, Renaissance to Romanticism*, North Carolina: The University of North Carolina, 2005

Coles, Alex, *The Transdisciplinary Studio*, Berlin: Stenberg Press, 2012

Colle, Marie-Pierre, *Latin American Artists in Their Studios*, New York: Vendome Press, 1994

Davidts, Wouter and Kim Paice, ed, *The Fall of the Studio: Artists at Work*, Amsterdam: Valiz, 2009

Doherty, Claire, ed, *Contemporary Art from Studio to Situation*, London: Black Dog Publishing, 2004

Esner, Rachel, Sandra Kisters and Ann-Sophie Lehmann ed, *Hiding, Making, Showing, Creation: The Studio from Turner to Tacita Dean*, Amsterdam: Amsterdam University Press, 2013

Fig, Jow, *Inside the Painter's Studio*, New York: Princeton Architectural Press, 2009

Hoffmann, Jens, ed, *The Studio*, Cambridge, MA: the MIT and Whitechapel Gallery, 2012

Hoffman, Jens and Christina Kennedy, ed, *The Studio*, Dublin: Dublin City Gallery Hugh Lane, 2006

Jacob, Mary Jane and Michelle Grabner, ed, *The Studio Reader: On the Space of Artists*, Chicago: University of Chicago Press, 2010

Jones, Caroline A, *Machine in the Studio: Constructing the Postwar American Artist*, Chicago: The University of Chicago Press, 1996

Kirwin, Liza and Lord, Joan, *Artists in Their Studios: Images from the Smithsonian's Archives of American Art*, New York: Collins Design, 2007

Lippard, Lucy R, ed, *Six Years: The dematerialization of the art object*, Berkeley and Los Angeles: University of California Press, 1997

Long, MJ, *Artists' Studios*, London: Black Dog Publishing, 2009

Madoff, Steven Henry, ed, *Art School (Propositions for the 21st Century)*, Cambridge, MA: The MIT Press, 2009

McNay, Michael, *Artists and Their Studios*, Devon: Angela Patchell Books, 2008

Newmann, Dana, *New Mexico Artists at Work*, New Mexico: Museum of New Mexico Press, 2005

O'Doherty, Brian, *Studio and Cube: On The Relationship Between Where Art Is Made And Where Art Is Displayed*, New York: Princeton Architectural Press, 2008

Perrella, Lynne, *Art Making & Studio Spaces: Unleash Your Inner Artist: An Intimate Look at 31 Creative Work Spaces*, Beverly, MA: Quarry Books, 2009

Richards, Judith Olch, ed, *Inside the Studio: Two Decades of Talks with Artists in New York*, New York: Distributed Art Publishers, 2004

Robertson, Brian, John Russell and Lord Snowdon, *Private View: The Lively World of British Art*, London: Thomas Nelson and Sons, 1965

Seidner, David, *Artists at Work: Inside the Studios of Today's Most Celebrated Artists*, New York: Rizzoli, 1999

Sjöholm, Jenny, *Geographies of the Artist's Studio #2*, London: Squid & Tabernacle, 2012

Taylor, Alex, *Perils of the Studio: Inside the Artistic Affairs of Bohemian Melbourne*, Melbourne: Australian Scholarly Publishing, 2007

Walkley, Giles, *Artists' Houses in London 1764–1914*, Vermont: Scholar Press, 1994

Waterfield, Giles, ed, *The Artist's Studio*, London: Hogarth Arts in association with Compton Verney, 2009

Wedd, Kit with Lucy Peltz and Cathy Ross, *Creative Quarters: The art world in London 1700–2000*, London: Museum of London, 2001

Williams, Jennifer et al., *The Artist in the Changing City*, London: The British American Arts Association, 1993

Winstanley, Paul, *Art School*, London: Ridinghouse, 2013

Notes on contributors

**Arantxa Echarte** is an artist and works as a Research Officer at Acme Studios. She works and lives in London. Arantxa gained her PhD (2012) from the University of the West of England, Bristol, after completing her MA in Art and Design at Robert Gordon University, Aberdeen, Scotland (2004) and BA in Fine Arts at the University of The Basque Country, Spain (2003). She is a Chartered Manager holding a CMI Level 5 Diploma in Management and Leadership.

Her work has been featured in international catalogues and publications and she has participated in international residencies and biennales. Her doctoral thesis, *Process Based Participatory and Interdisciplinary Artistic Practice* was published by Scholar's Press in 2014, and essays and chapters have been included in the *International Journal of the Arts in Society*, vol 7, no 4, 2007, and vol 4, no 1, 2009; *Between: Ineffable Intervals*, Wild Conversations Press, 2012, and *Theorizing Visual Studies: Writing Through the Discipline*, London: Routledge, 2012.

**Graham Ellard** is an artist. He has held a full-time teaching position at Central Saint Martins, University of the Arts London, since 1998, and is currently Professor of Fine Art, and Research Leader for the Art Programme.

As an artist he has collaborated with Stephen Johnstone since 1993. Their work has been exhibited internationally in museums and galleries including; Centre Georges Pompidou, Paris; Tate Liverpool; Ikon Gallery, Birmingham; MOCA, Sydney; Chicago Architecture Foundation; Rotterdam International Film Festival; the Victoria and Albert Museum, London; MAXXI, Rome; Site Gallery, Sheffield; Triennale Design Museum, Milan; The Estorick Collection, London; Satellite Gallery, Aichi Triennale, Nagoya, Japan; Anthology Film Archives, New York. Their book, *Anthony McCall: Notebooks and Conversations* was published by Lund Humphries in March 2015.

**Hugo Glendinning** has been working as a photographer, based in London, for 20 years. His output stretches across the cultural industries from Fine Art collaborations in video and photography, through production and performance documentation to portrait work.

He has worked with most leading British theatre and dance companies and is regularly commissioned by the Royal Shakespeare Company, National Theatre and Royal Opera House.

He has published and exhibited work internationally, notably his continuing project of documentation and the investigation of performance photography with Tim Etchells and Forced Entertainment Theatre Company. His work with Franco B, Matthew Barney, Martin Creed, Paola Pivi and Yinka Shonibare, recording both performances for camera and public performances or events, is in private collections and museums around the world.

A regular visiting lecturer at universities around the UK, Hugo was an AHRC Fellow at Exeter University in the Department of Drama between 2008 and 2011. In the last few years his collaboration with Professor Adrian Heathfield, making performance lectures, has developed into a range of other projects, including a series of five films co-directed with Heathfield of conversations with leading philosophers and thinkers.

**Jonathan Harvey** is Chief Executive of Acme Studios, which he founded with David Panton in 1972. He completed a BA in Fine Art at Reading University (1967–71) and an MA at Chelsea School of Art (1971–72).

He ran The Acme Gallery (1976–81) in Covent Garden which established a significant reputation for its uncompromising approach to the presentation of installation and performance work. In 1977, he co-founded TSW-Television South West (1982–92) the ITV franchise holder for the South West of England. He worked as their Arts Consultant and as an associate producer on arts and experimental programmes, and co-curated two pioneering international site-specific public art projects, TSWA 3D (1987) and TSWA's Four Cities Projects (1990).

He was Chairman of Arnolfini, Bristol (1993–2006), where he oversaw their major capital lottery project at Bush House. He played a key role in establishing a national body to represent affordable studio providers and in 2006 became a founding trustee of the National Federation of Artists' Studios Providers. He is currently a trustee of High House Production Park Ltd, Purfleet, Essex.

He and David Panton were appointed Officers of the Order of the British Empire (OBE) in the New Year 2014 Honours List for services to the arts.

**HAT Projects** is an award-winning practice led by Hana Loftus and Tom Grieve, with particular expertise in cultural projects and listed buildings. Of their major projects, both the Jerwood Gallery in Hastings and High House Artists' Studios won RIBA awards and the Jerwood Gallery was mid-listed for the 2013 Stirling Prize. They are currently undertaking work on Shoreditch Town Hall and the Gasworks gallery and studio complex in South London, alongside housing and commercial projects.

HAT Projects are known for elegant, rational and materially rich buildings that encourage exploration and engagement, and are finely tuned to their functions and their contexts. Described as one of Britain's brightest young practices in the Observer, they were runners-up for Young Architect of the Year 2013 and were recently named RIBA East Emerging Architect of the Year.

**Jeremy Till** is an architect, writer and educator. He is Head of Central Saint Martins and Pro Vice-Chancellor of University of the Arts London. Previously he was Dean of Architecture and the Built Environment at the University of Westminster, and Professor of Architecture and Head of School of Architecture at the University of Sheffield.

His extensive written work includes *Flexible Housing* with Tatjana Schneider, 2007; *Architecture Depends,* 2009; and *Spatial Agency* with Nishat Awan and Tatjana Schneider, 2011. All three of these won the RIBA President's Award for Outstanding Research, an unprecedented sequence of success in this prestigious prize. As an architect he worked with Sarah Wigglesworth and in particular on their own house and office, 9 Stock Orchard Street, London.

Copyright 2015 Black Dog Publishing Limited,
London, UK, and the authors and artists,
all rights reserved.

Black Dog Publishing Limited
10a Acton Street
London WC1X 9NG
United Kingdom

Tel  +44 (0)20 7713 5097
Fax  +44 (0)20 7713 8682
info@blackdogonline.com
www.blackdogonline.com

Cover Image and chapter title images on
p 17, p 36, p 50, p 66, p 101 and p 120:
Hugo Glendinning, 2011

Designed by Sylvia Ugga at Black Dog Publishing.

British Library Cataloguing-in-Publication Data.
A CIP record for this book is available from the
British Library.
ISBN 978 1 910433 08 9

Black Dog Publishing Limited, London, UK, is an
environmentally responsible company. *Studios For
Artists* is printed on sustainably sourced paper.

**black dog
publishing**

london uk

art design fashion
history photography
theory and things

www.blackdogonline.com

KNOWLEDGE TRANSFER
PARTNERSHIPS